15 May – 13 June 1998

ARIKHA

Marlborough Fine Art (London) Ltd
6 Albemarle Street
London W1X 4BY
Telephone (0171) 629 5161
Telefax (0171) 629 6358

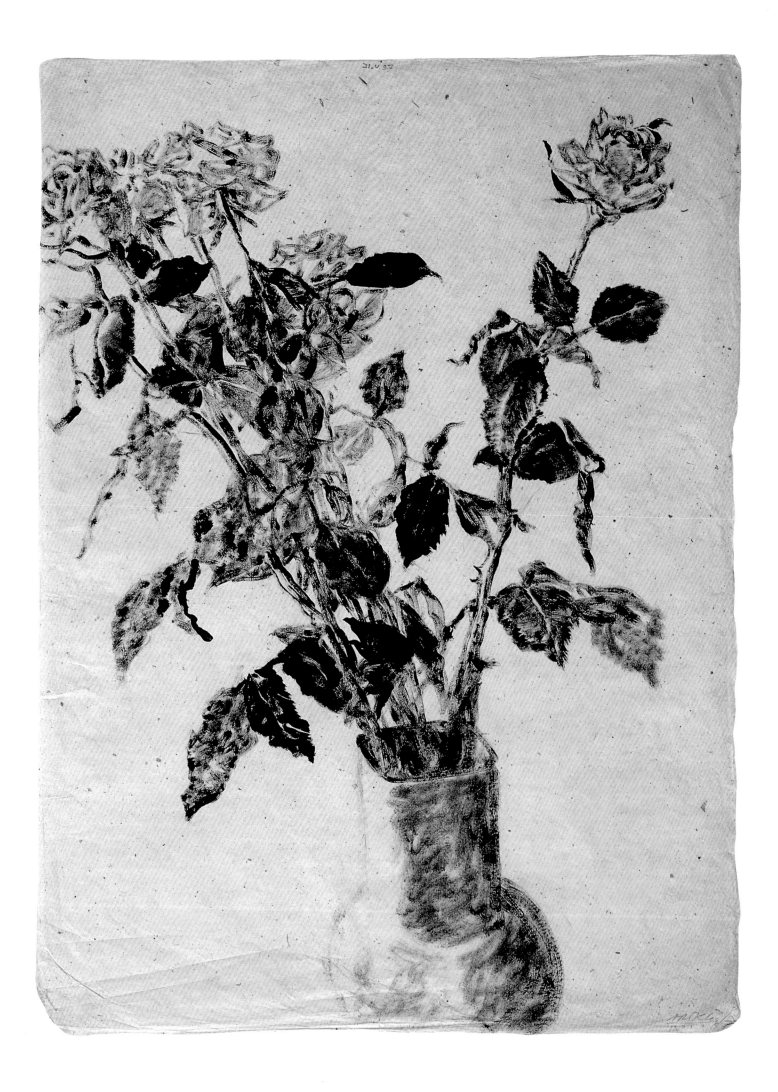

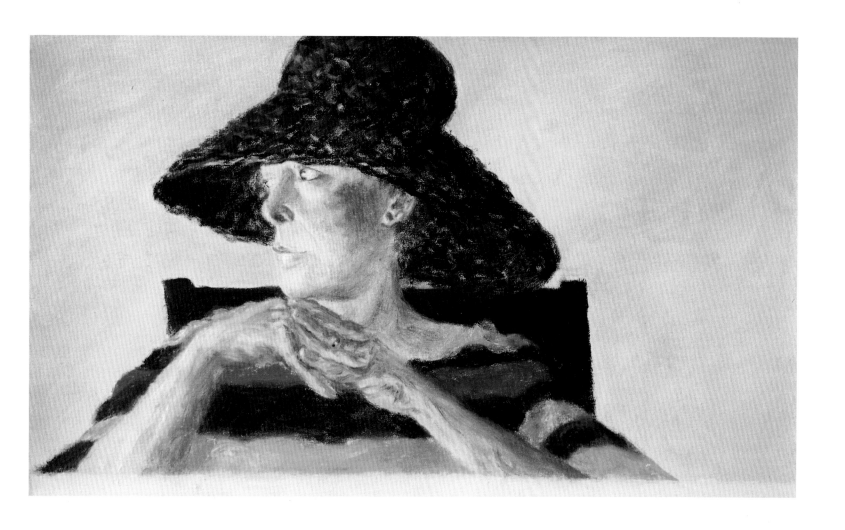

1
ROSES
Jerusalem, 1997
brush and sumi ink on nepal paper
67.5 × 50 cm. / 26⅝ × 19⅝ in.
s.l.r. d.u.c. 31.V 97.

2
ANNE IN SUMMER WITH STRAW HAT
Jerusalem, 1996
oil on canvas
38 × 65 cm. / 14¹⁵⁄₁₆ × 25⅝ in.
s.l.r. d.v 13 VI 96

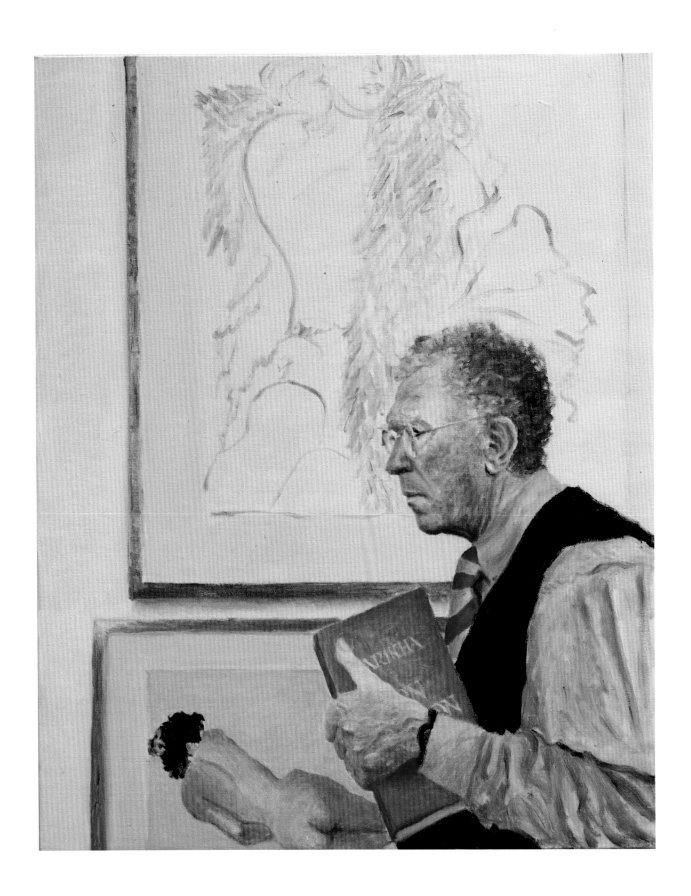

3

SELF PORTRAIT IN PROFILE
Paris, 1997
oil on canvas
80.8 × 64.7 cm. / 31½ × 25¼ in.
d. verso 8–9 II 1997
Florence, Galleria degli Uffizi
not exhibited

4

THE BALCONY
Jerusalem, 1997
oil on canvas
100 × 81 cm. / 39⅜ × 31⅞ in.
s.l.l d.verso 21 VI 97

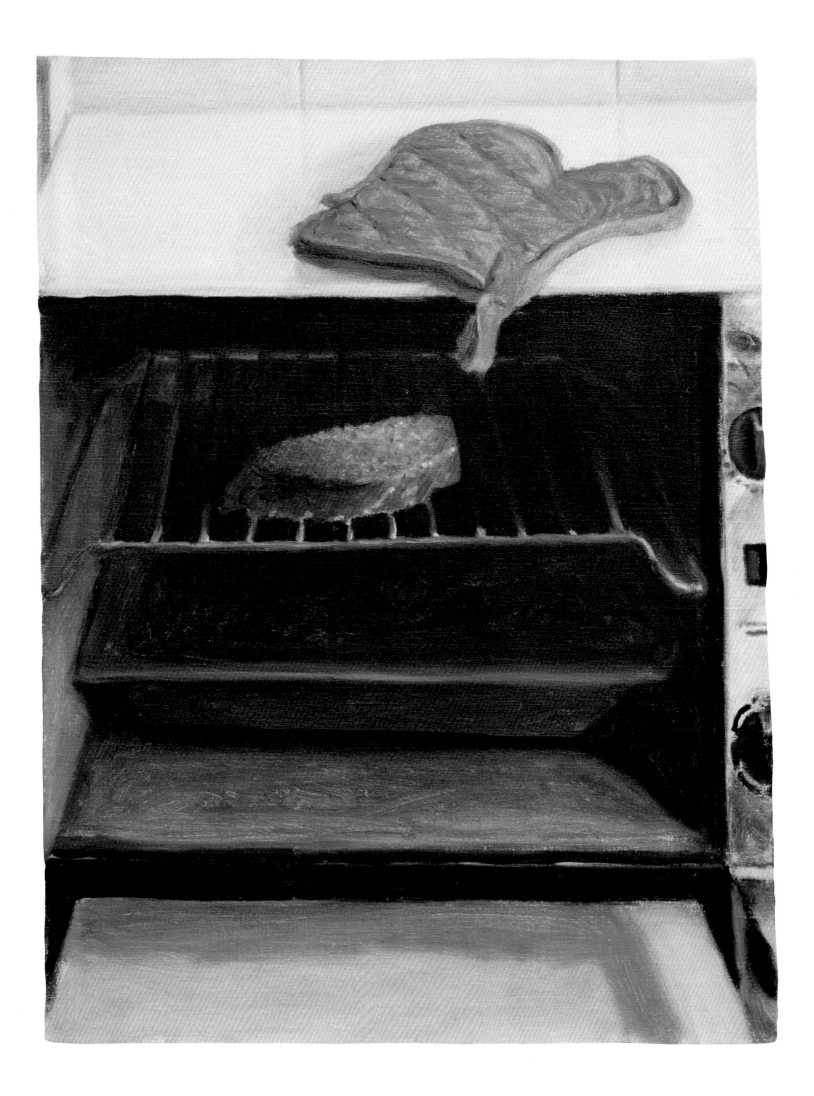

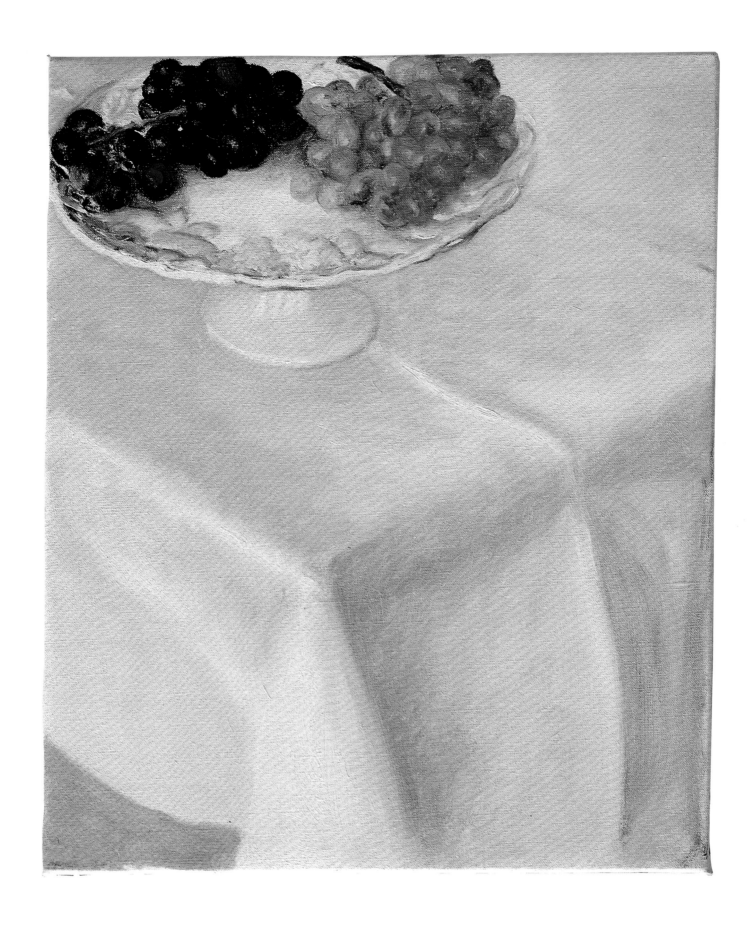

5

MORNING TOAST
Jerusalem, 1996
oil on canvas
61 × 46.2 cm. / 24 × 18³⁄₁₆ in.
s.l.c. d.verso 6 VII 96

6

STILL-LIFE WITH GRAPES
Paris, 1997
oil on canvas
46 × 38 cm. / 18¹⁄₈ × 14¹⁵⁄₁₆ in.
s.l.l. d.verso 18 IV 97

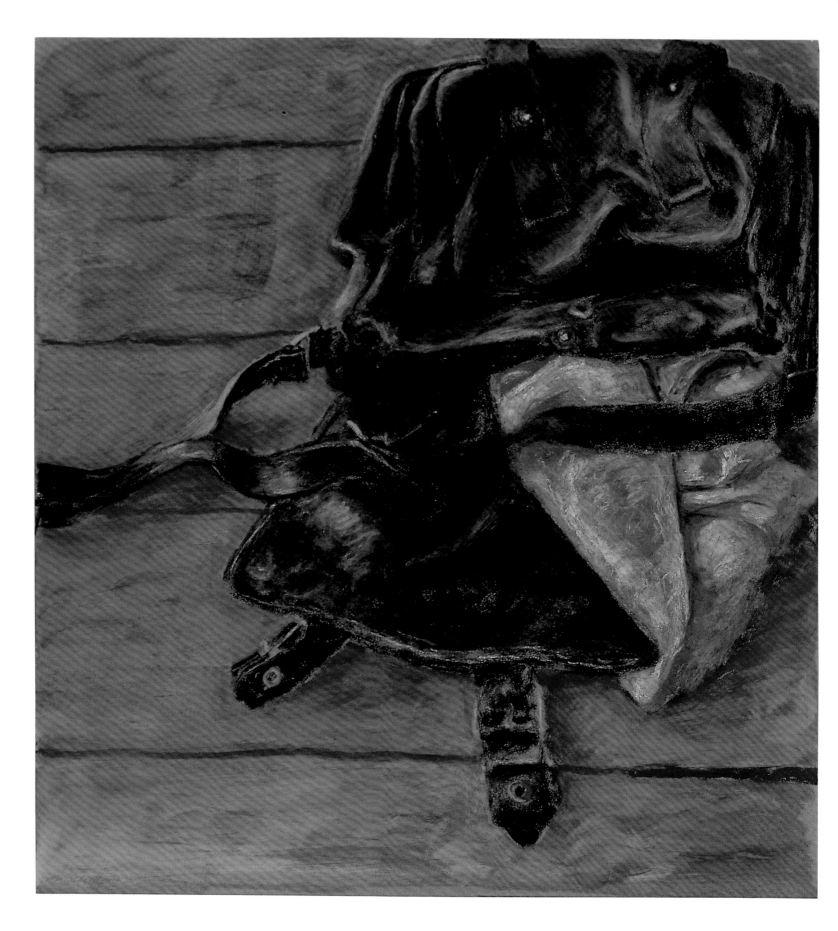

7

GREEN SCARF IN BLACK BAG ON RED FLOOR
Paris, 1993
pastel on grey board
53 × 50 cm. / 20⅞ × 19⅝ in.
s.l.l. d.l.r.29 I 93

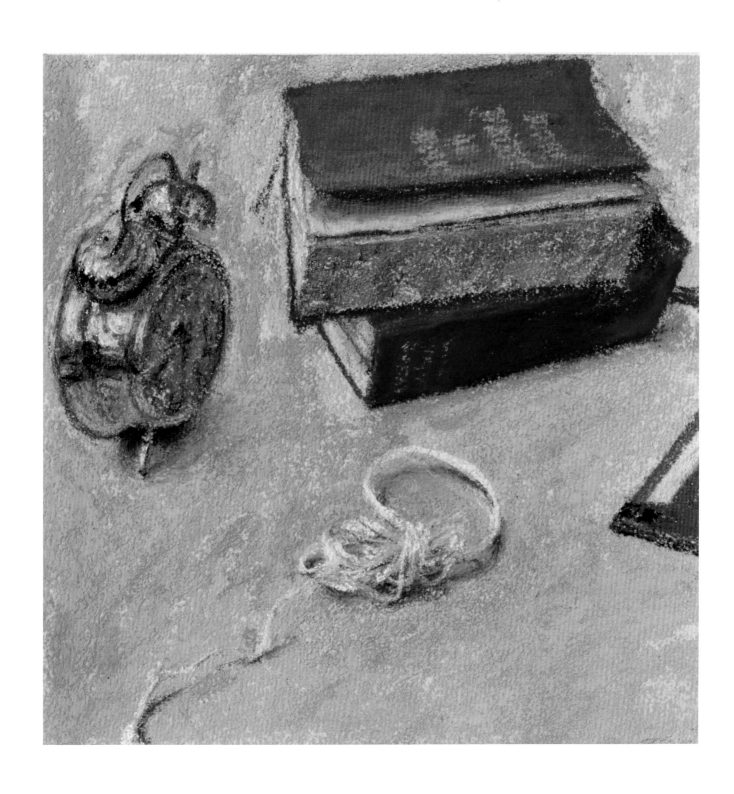

8

BAEDECKER

Paris, 1996

pastel on prepared paper

28 × 27.5 cm. / 11 × 10⅝ in.

s.l.r. d.u.l. 11 XI 96

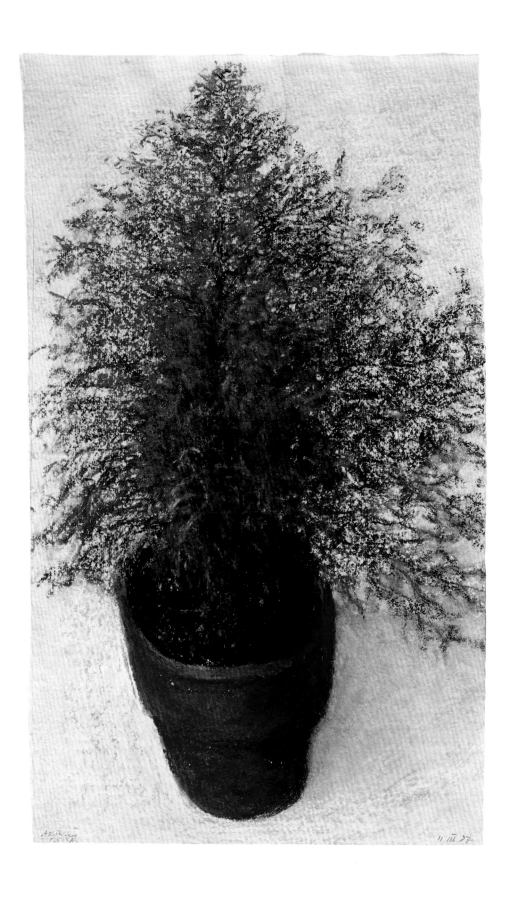

9
CUPRESSUS
Paris, 1997
pastel on laid wove paper
52 × 30.5 cm. / 20½ × 12 in.
s.l.l. d.l.r. 11 III 97

10
NUDE SELF-PORTRAIT, DOUBLE STUDY
Paris, 30 June 1995
soft graphite on laid Sennelier paper
67 × 51.5 cm. / 26⅜ × 20⅛ in.
s.l.l. d.u.l

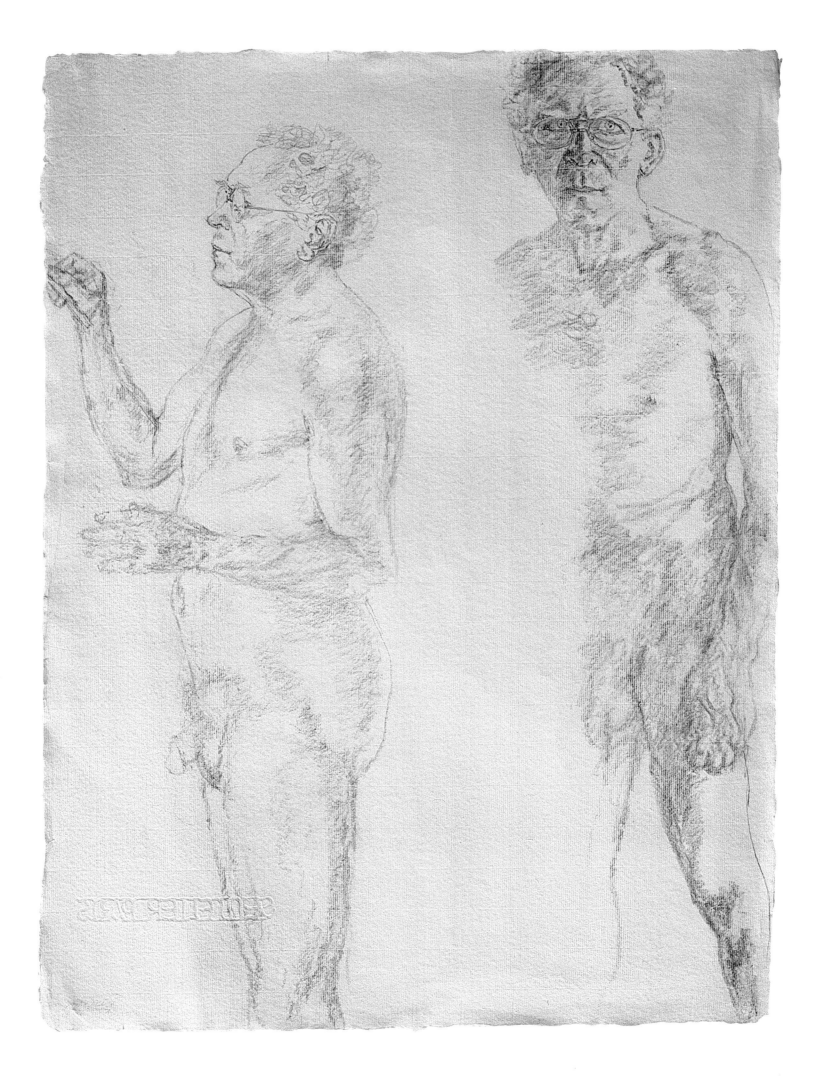

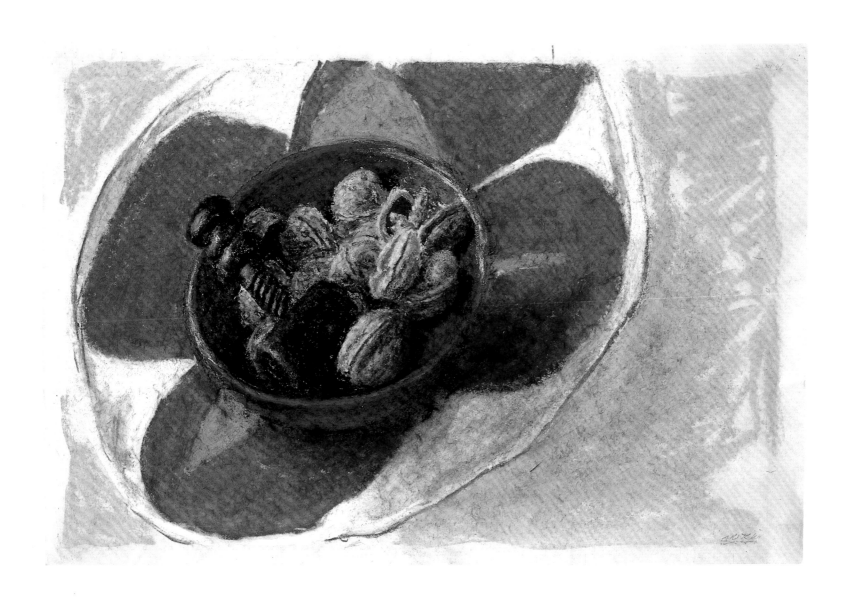

11

NUTS

Paris, 1996

pastel on japan paper

35 × 53.5 cm. / (paper) 13⅓ × 21¹/₁₆ in.

s.l.r. d.u.r. 2 XI 96

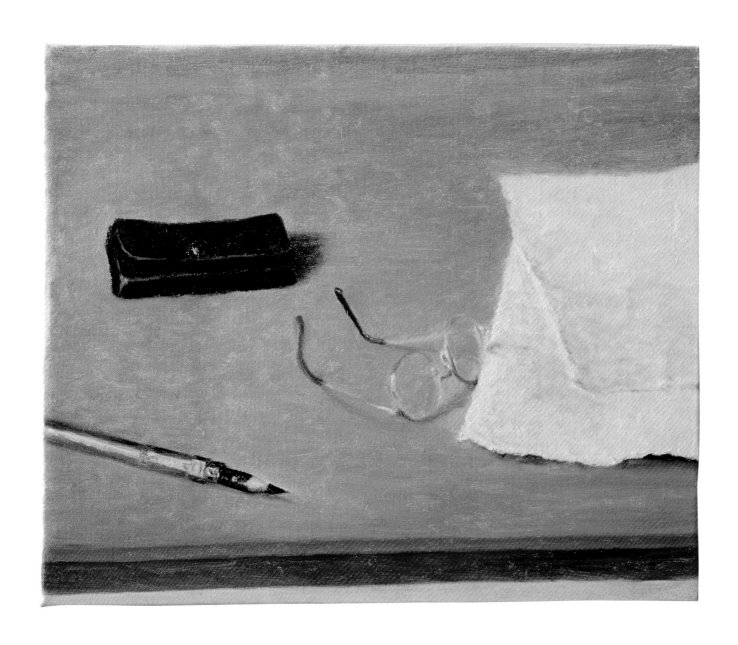

12

STILL-LIFE WITH TWO SHEETS OF PAPER

Paris, 1997

oil on canvas

38 × 46 cm. / 14^{15}⁄$_{16}$ × 18^{1}⁄$_{8}$ in.

s.u.l. d.verso 26 IV 97

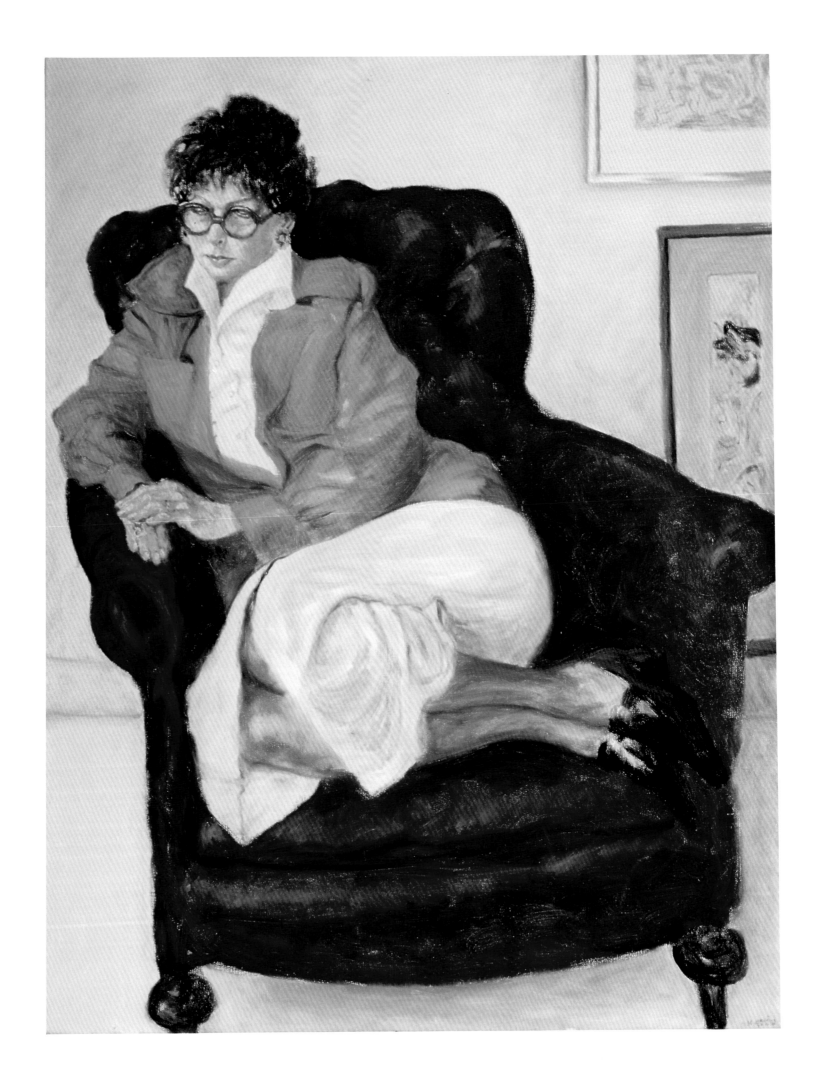

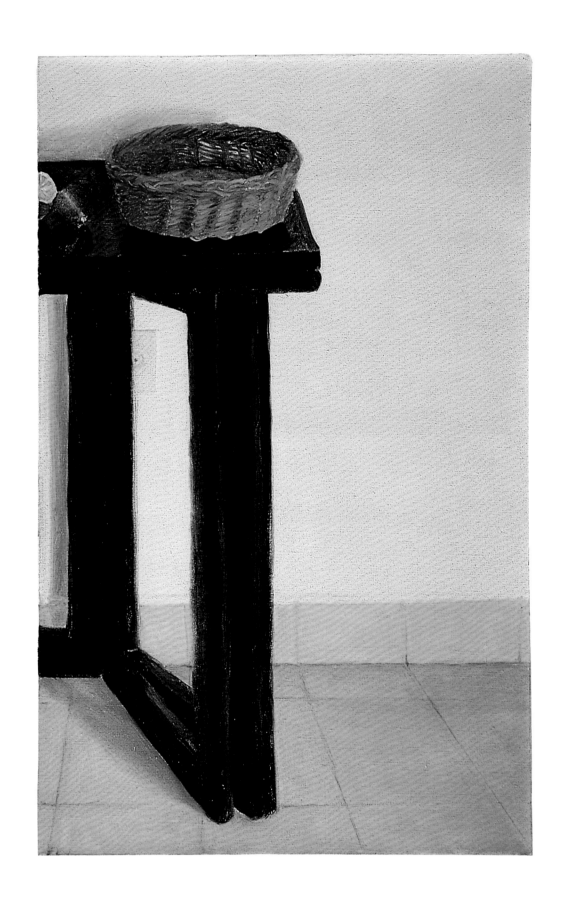

13
ANNE IN GREEN WITH GLASSES
Paris, 1996
oil on canvas
116 × 89 cm. / 45⅝ × 35 in.
s.l.r. dated on reverse 22 III 96

14
EMPTY BASKET
Jerusalem, 1996
oil on canvas
99.5 × 63.5 cm. / 39⁵⁄₁₆ × 24⅞ in.
s.l.r. d.verso 9 VII 96

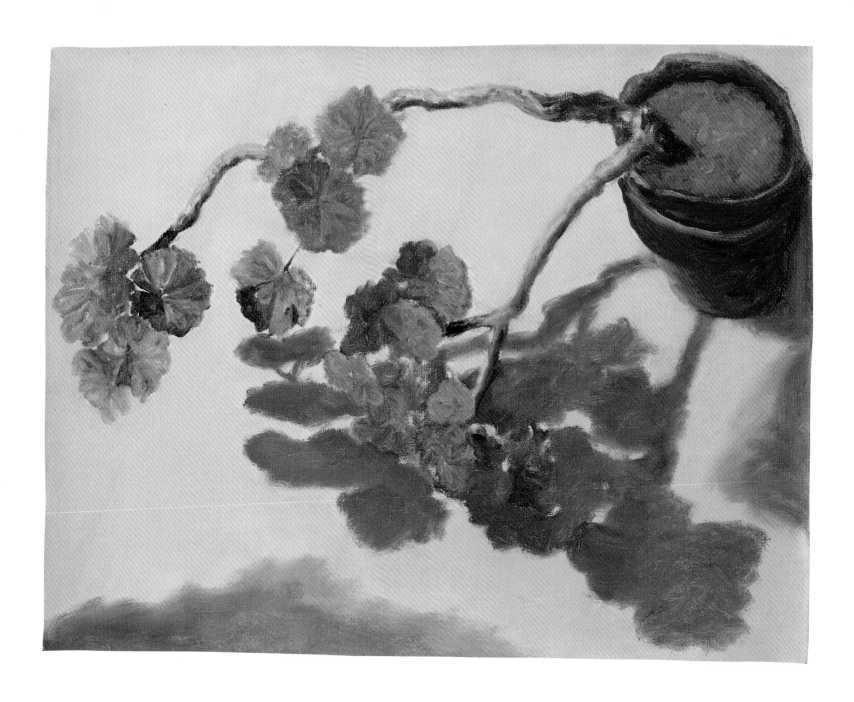

15

PLANT AND SHADOW
Jerusalem, 1996
oil on canvas
54 × 65 cm. / 21¼ × 25⅝ in.
s.l.l. d.verso 22 VI 96

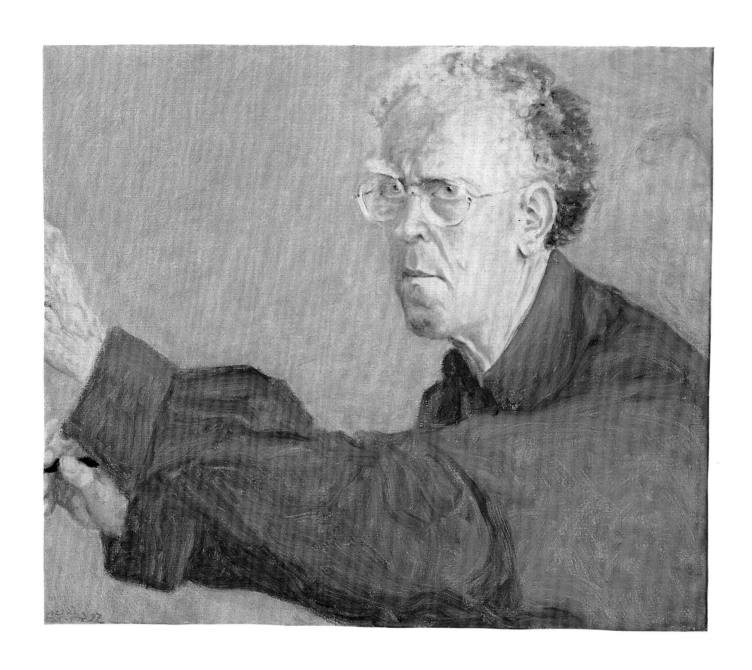

16

SELF-PORTRAIT IN A VIOLET SHIRT

Paris, 1997

oil on canvas

46 × 55 cm. / 18⅛ × 21⅝ in.

s.l.l. dated on reverse 16 I 97

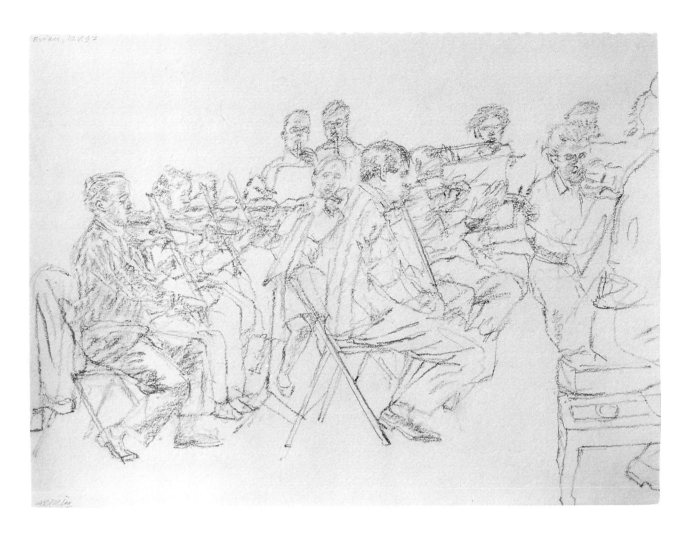

17

THE LISZT ORCHESTRA
Evian, 10 May 1997
Conté crayon on rag paper
22.1 × 30.5 cm. / 8¾ × 12 in.
s.l.l. d.u.r.

18

WATCHING CARMEN
Paris, 26 February 1997
brush and ink on rag paper
19.5 × 15.2 cm. / 7⅝ × 6 in.
s.u.r. d.u.l.

19

EDINBURGH, THE MOUNT
Edinburgh, 7 December 1993
brush and ink on nepal paper
22 × 15.3 cm. / 8⅝ × 6 in.
s.l.c. d.u.c.

20

YO YO MA AT THE CHÂTELET
Paris, 13 January 1994
brush and ink on nepal paper
15.4 × 17 cm. / 6 × 6¹¹⁄₁₆ in.
s.l.l. d.u.l.

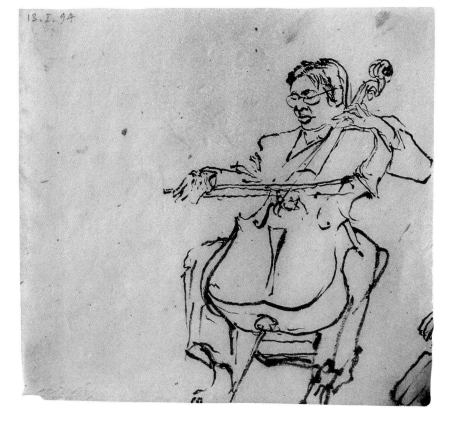

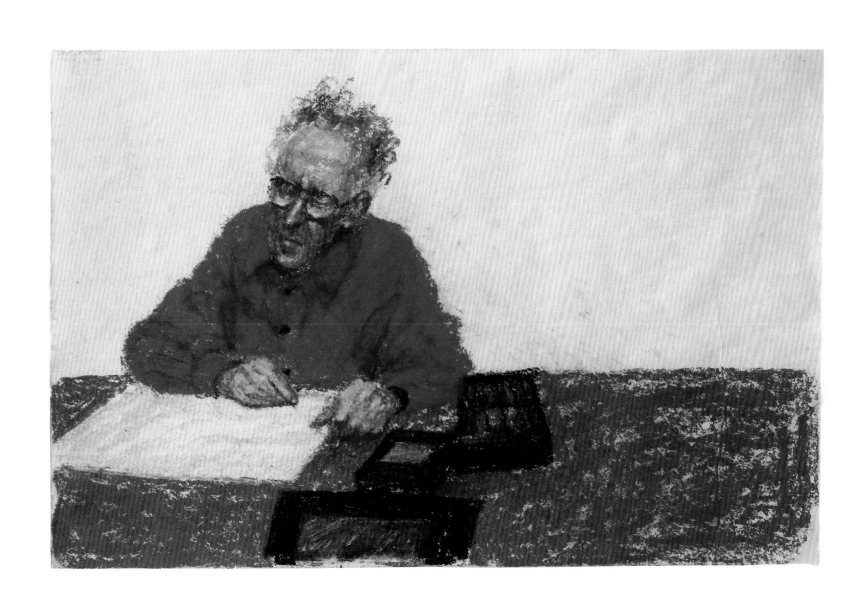

21
SELF-PORTRAIT AT WORKING TABLE
Paris, 1996
pastel on japan paper
33.3 × 51.5 cm. / 13¹/₁₆ × 20⅛ in.
s.u.l. d.u.r. 5 x 96

22

CLOUDS

Paris, 1997

oil on canvas

97 × 162 cm. / 38¼ × 63⅞ in.

s.u.c. d. verso 27 VII 97

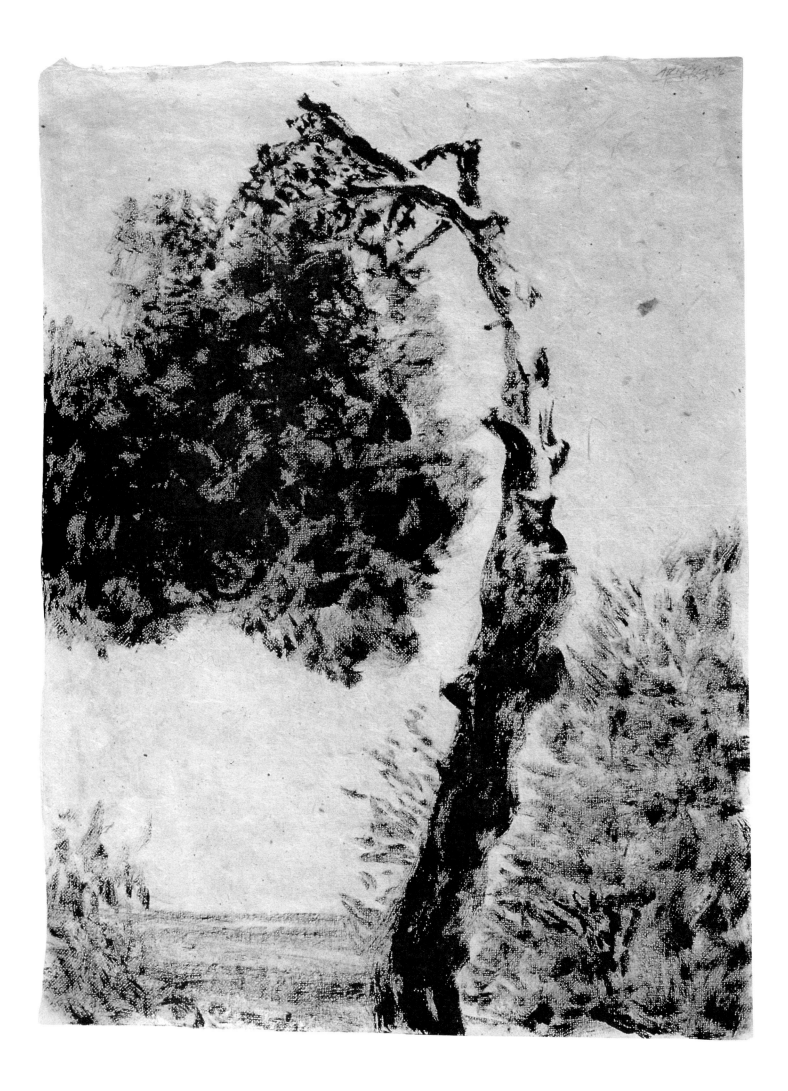

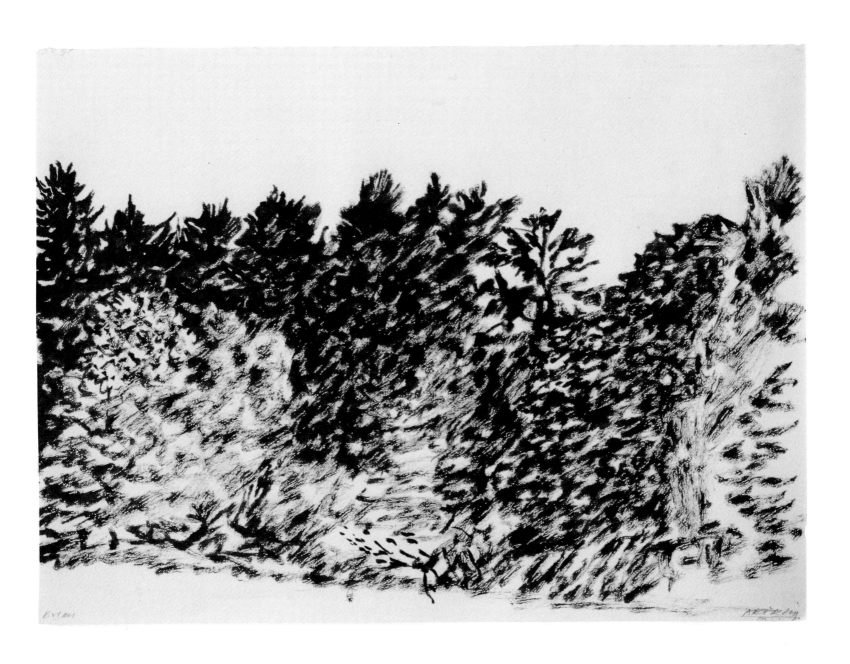

23

THE INJURED PINE
Jerusalem, June 1996
brush and sumi ink on nepal paper
40.1 × 30.5 cm. / 15¾ × 12 in.
s.& d.u.r.

24

TREES AT EVIAN
Evian, 10 May 1997
brush and ink on rag paper
22.1 × 30.5 cm. / 8¾ × 12 in.
s.l.r. d.l.l.

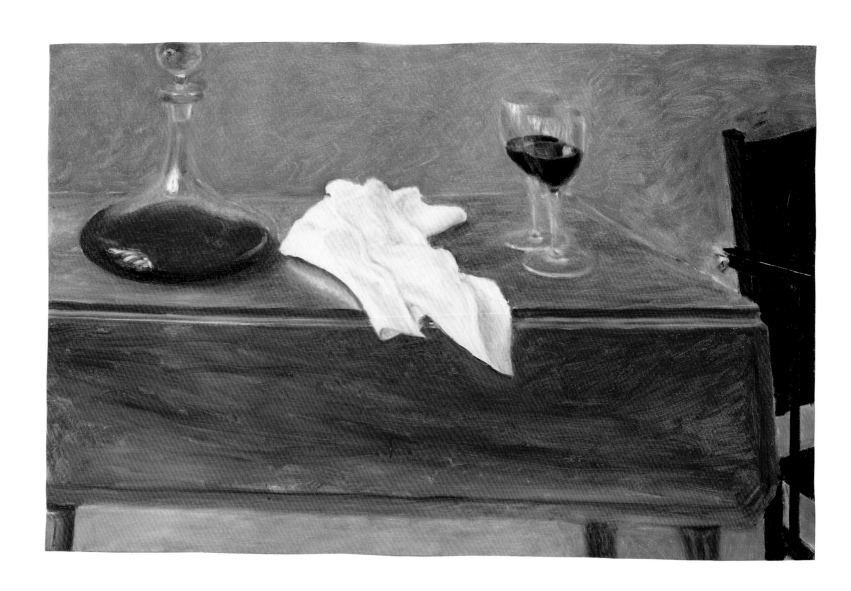

25
SAINT-EMILION
Paris, 1997
oil on canvas
64.7 × 100 cm. / 25¼ × 39⅜ in.
s.u.r. d.verso 24 VII 97

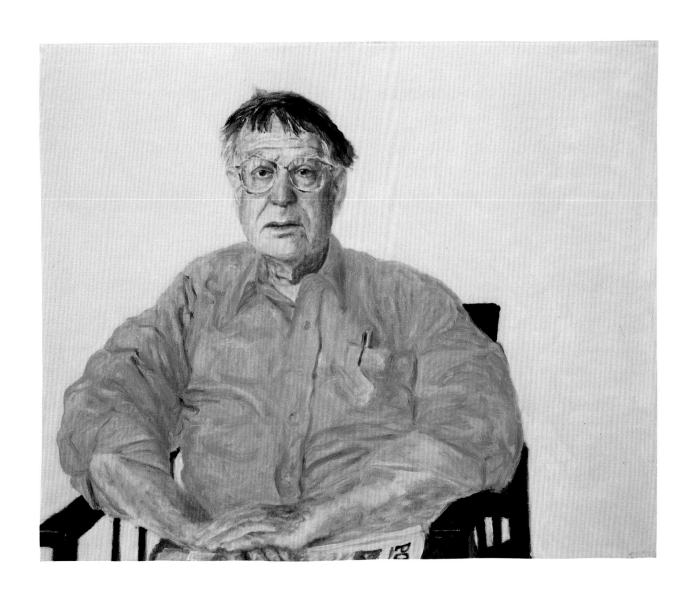

26
HERBERT PUNDIK
Paris, 1997
oil on canvas
65 × 81 cm. / 25⅝ × 31⅞ in.
s.l.r. d.u.r., 25 VIII 97
Hillerød, Nationalhistorisk museum på Frederiksborg
not exhibited

27
VIEW OF RATISBONNE
Jerusalem, 1996
brush and sumi ink on laid Arches paper
49.8 × 63.3 cm. / 19⅝ × 24⅞ in.
s.& d.u.r.

28
ANNE IN PROFILE, WITH CLOSED EYES
Paris, 1994
charcoal on japan paper
47.5 × 65 cm. / 18¾ × 25⅝ in.
s.& d.l.r.

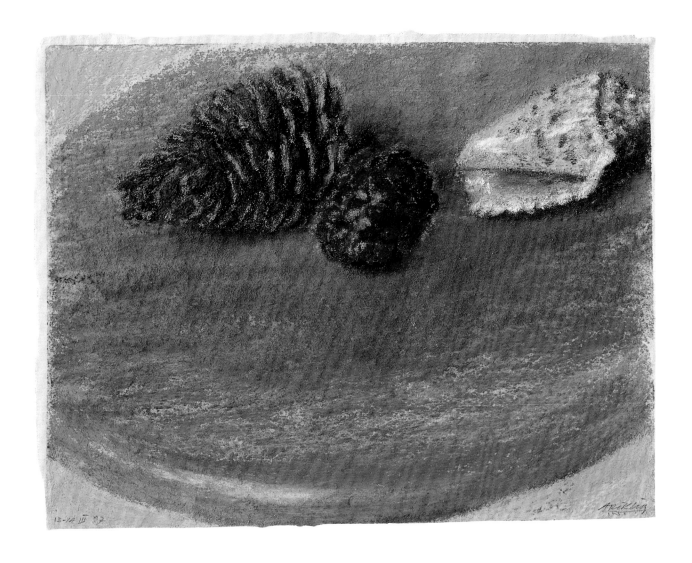

29

SHELL AND CONES
Paris, 1997
pastel on japan paper
24 × 31 cm. / 9½ × 12¼ in.
s.l.r. d.l.l. 13–14 III 97

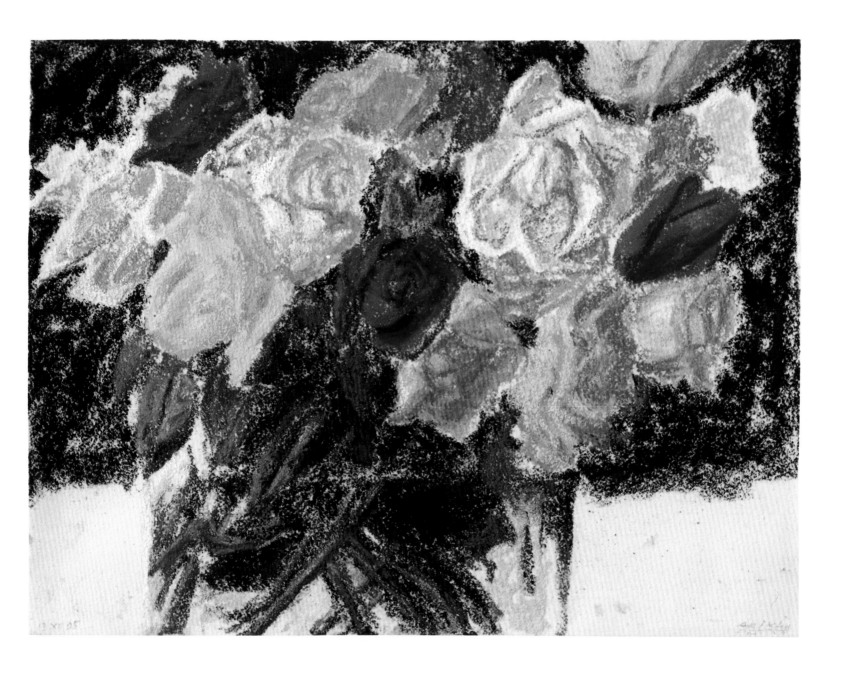

30
ROSES
Paris, 1995
pastel on prepared paper
30 × 40 cm. / 11¾ × 15¾ in.
s.l.r. d.l.l. 13 XII 95

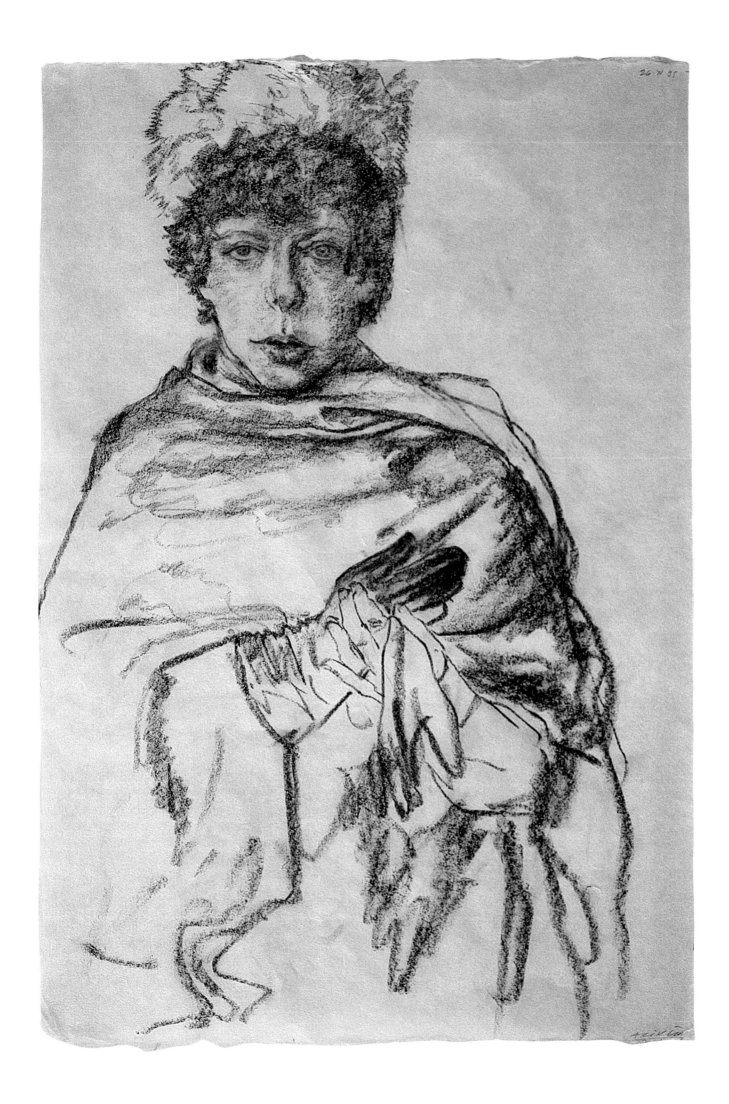

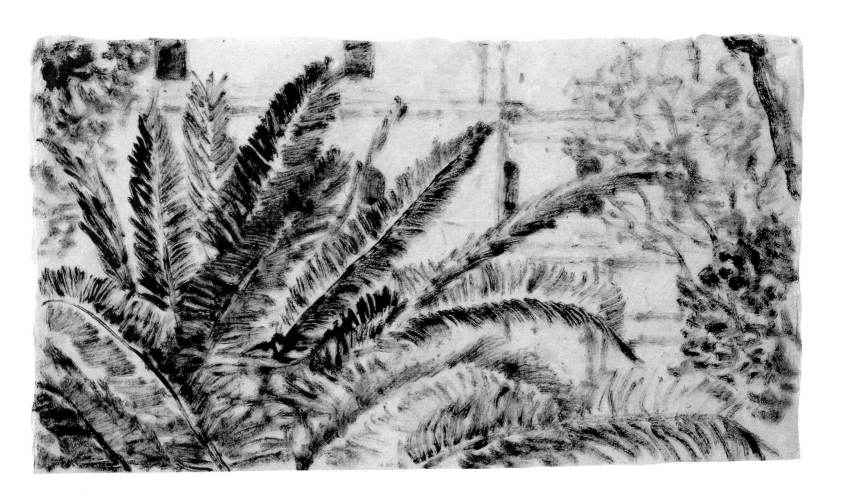

31
ANNE TAKING OFF A GLOVE
Paris, 26 November 1995
soft charcoal on japan paper
65 × 45 cm. / 25⅝ × 17¾ in.
s.l.r. d.u.r.

32
VEGETATION
Jerusalem, 16 July 1996
brush and sumi ink on nepal paper
26 × 47.5 cm. / 10¼ × 18⅝ in.
s.l.r. d.l.c.

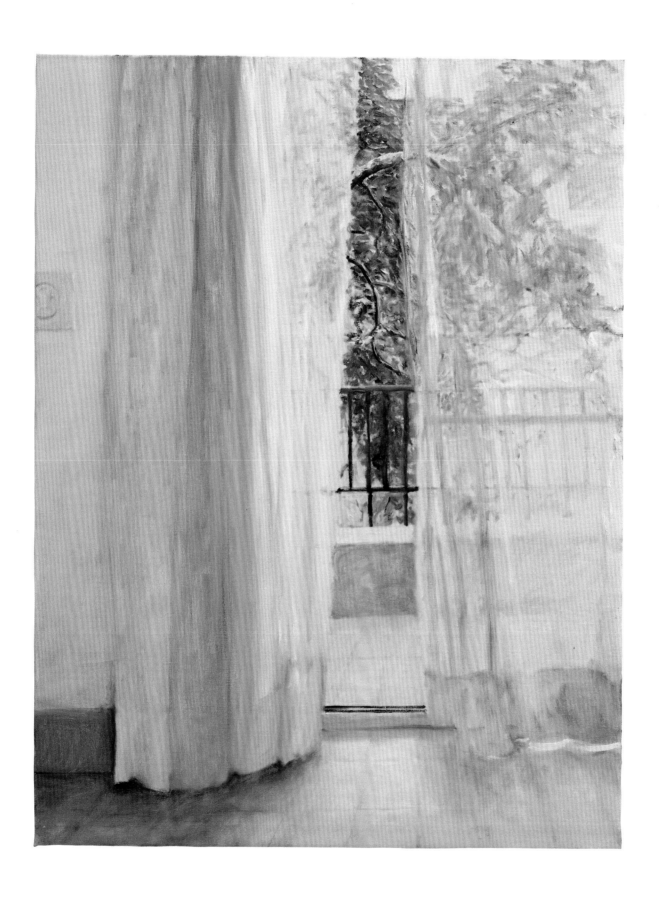

33
THE CURTAIN
Jerusalem, 1997
oil on canvas
116 × 89 cm. / 45⅝ × 35 in.
s.l.l. d.verso 25 VI 97

34
INSIDE AND OUTSIDE
Paris, 1996
oil on canvas
162.1 × 130 cm. / 63⅞ × 51³⁄₁₆ in.
s.& d.l.r. d.verso IV 96

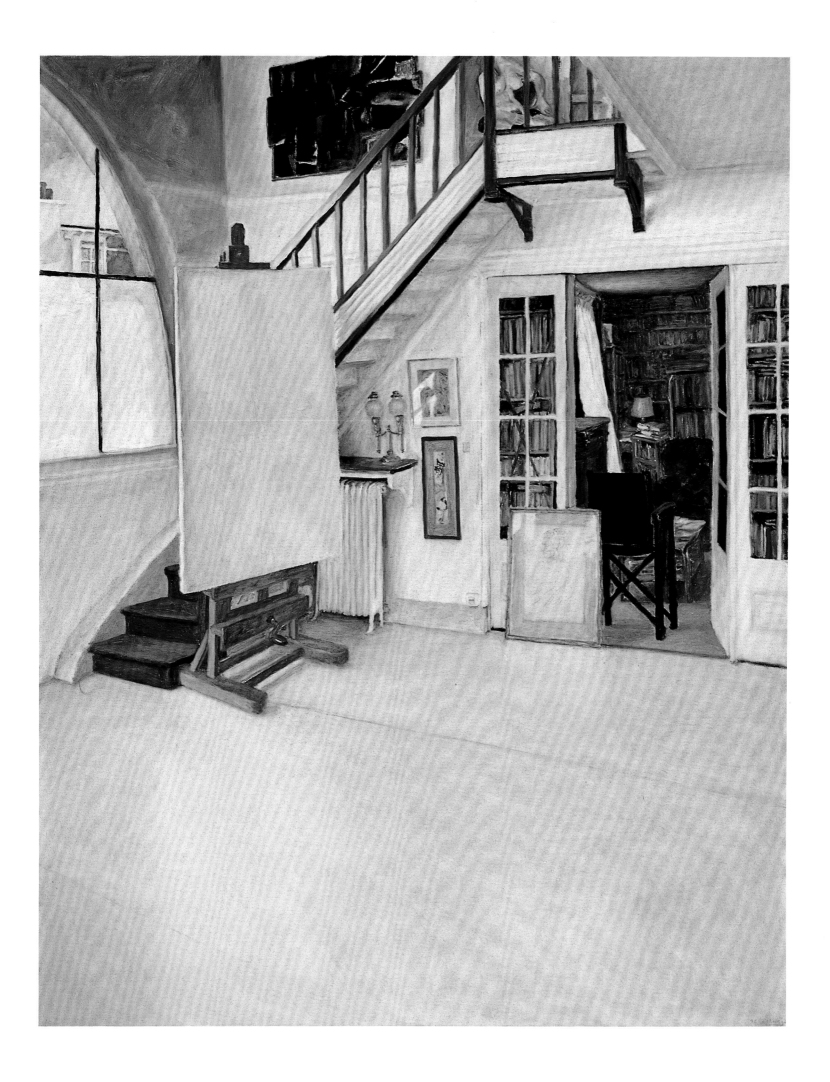

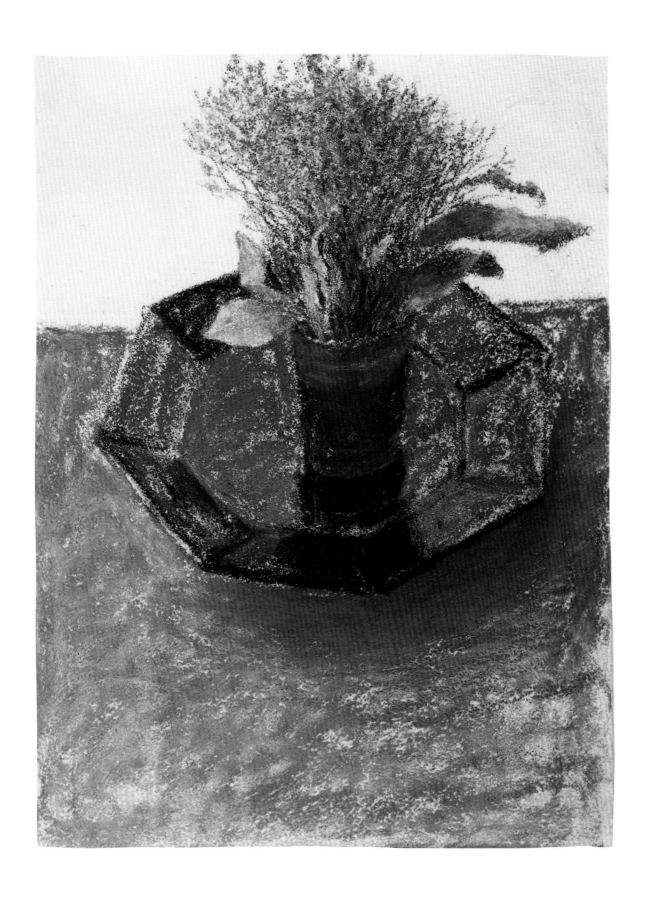

35
THYME AND LAUREL
Paris, 1996
pastel on sand-paper
40 × 30 cm. / 15¾ × 11¾ in.
s.l.r.

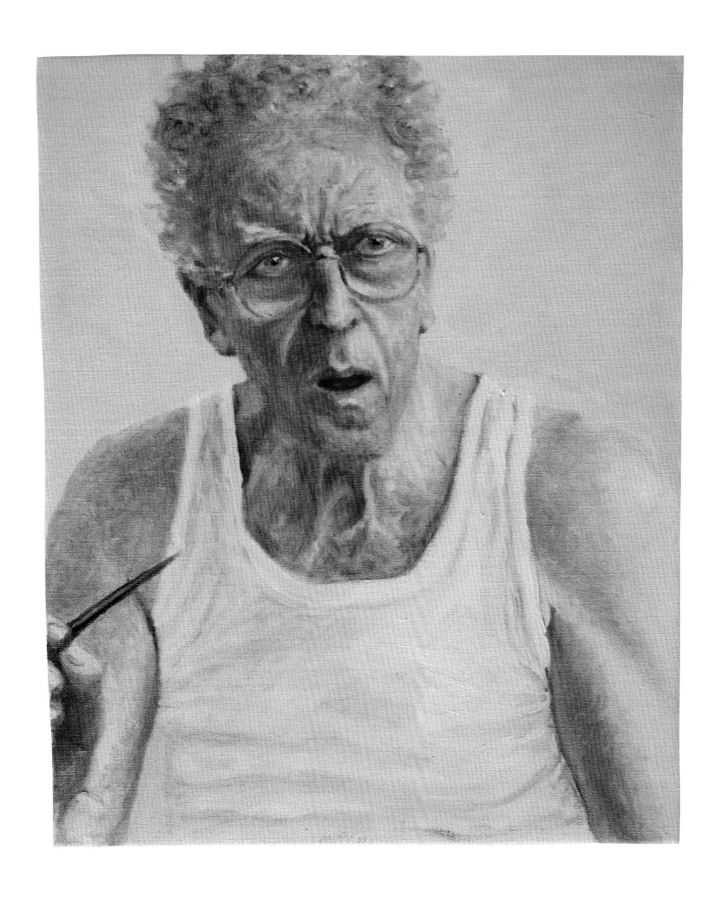

36

SELF-PORTRAIT IN UNDERSHIRT
Paris, 1997
oil on canvas
46 × 38 cm. / 18⅛ × 14¹⁵⁄₁₆ in.
s.l.c. dated on reverse 28–29 I 97

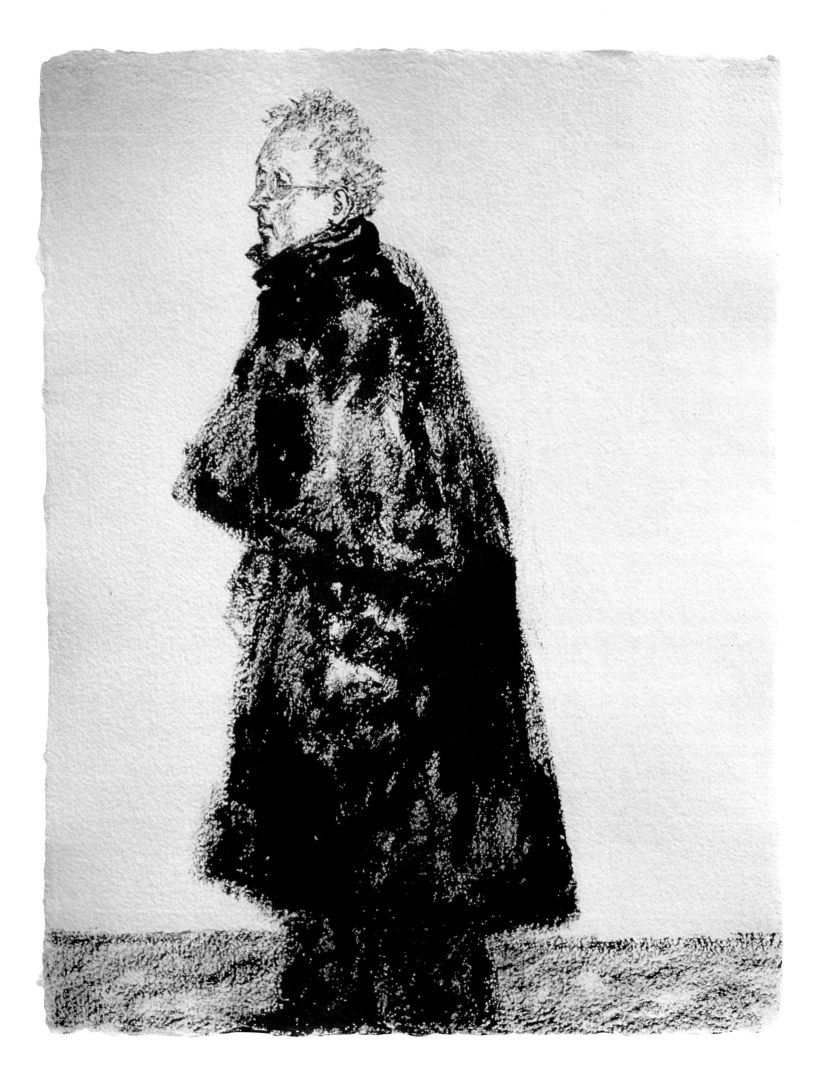

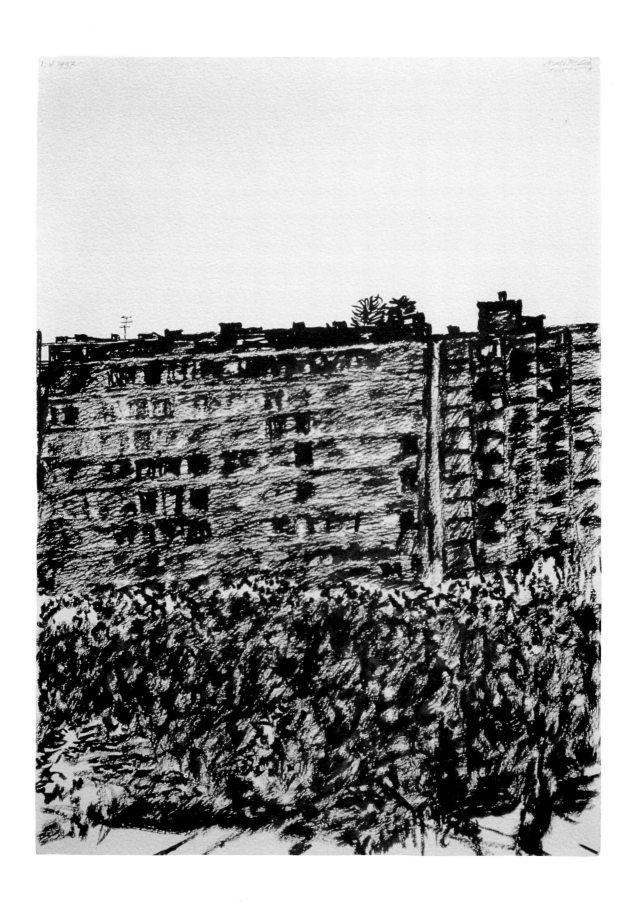

37
SELF-PORTRAIT ON A RAINY DAY
Paris, 5 October 1996
brush and sumi ink on rough
grey wove paper
64.2 × 49.7 cm. / 25¼ × 19½ in.
s.u.r. d.u.l.

38
THE BUILDINGS BEHIND THE AUGUSTINES' GARDEN
Paris, 1997
brush and ink on flaxen tinted wove paper
37 × 27 cm. / 14½ × 10⅝ in.
s.u.r. d.u.l.,1 V 97

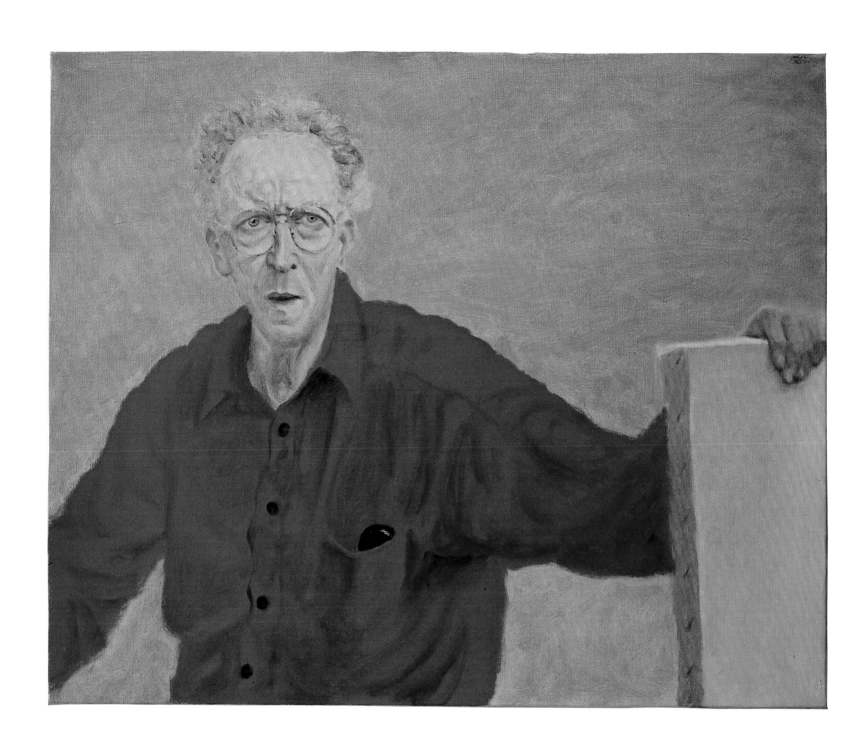

39

SELF-PORTRAIT IN A RED SHIRT
Paris, 1997
oil on canvas
64.5 × 81 cm. / 25¼ × 31⅞ in.
s.u.r. d.verso 4–5 V 97

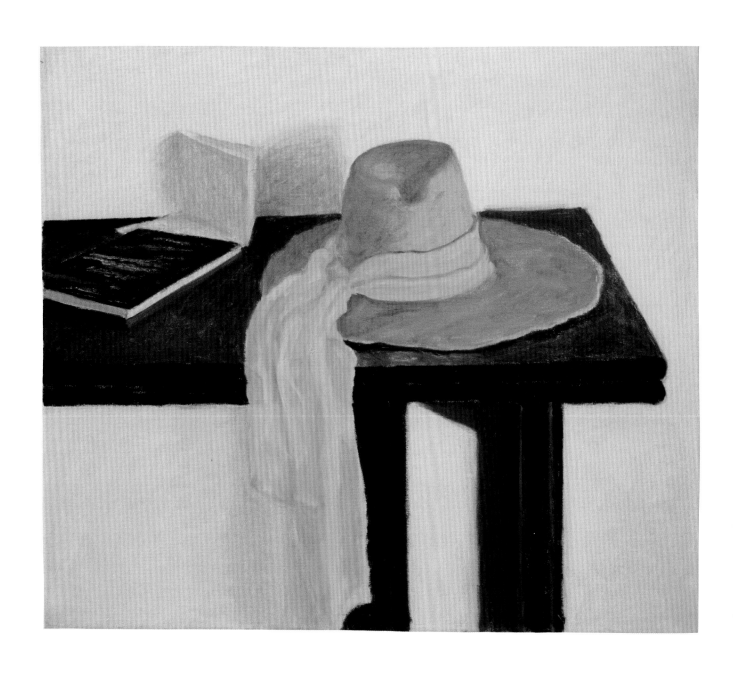

40
THE YELLOW HAT
Jerusalem, 1997
oil on canvas
60 × 70 cm. / 23⅝ × 27½ in.
s.u.r. d.verso 5 VI 97

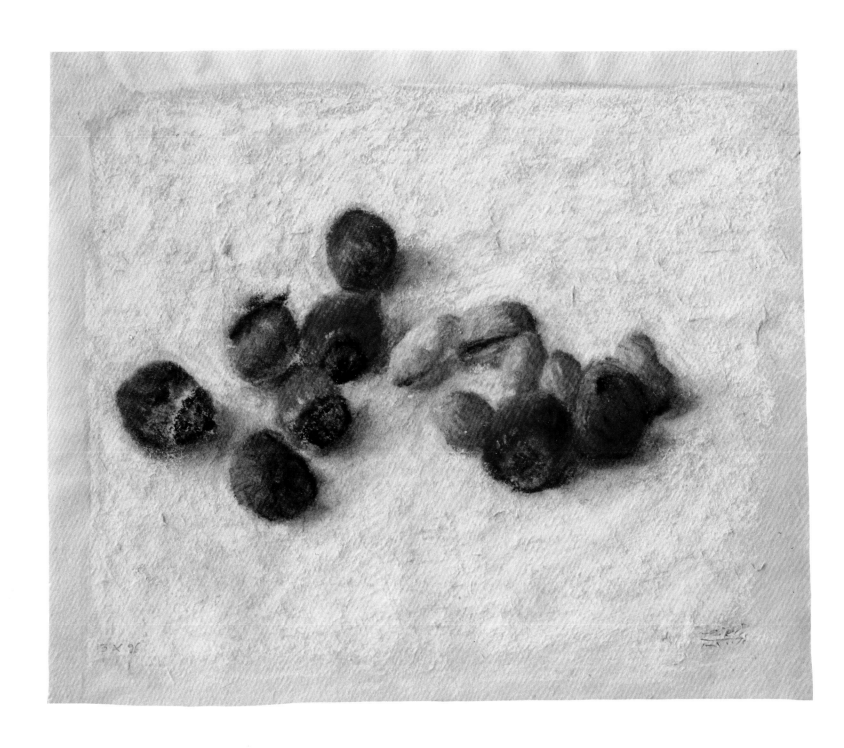

41
HAZELNUTS AND PISTACHIOS
Paris, 1996
pastel on japan paper
21.5 × 26 cm. / 8¼ × 10¼ in.
s.l.r. d.l.l. 3 x 96

SOLO EXHIBITIONS

1952 Tel Aviv, *Galeria Zeira*, Paintings & Drawings

1953 Jerusalem, *Artists' House*, Paintings, Drawings, Illustrations

Jerusalem, *The Bezalel National Museum*, Paintings, Drawings, Woodcuts

1954 Stockholm, *Galerie Moderne*, Paintings & Drawings

Copenhagen, *Athenæum Kunsthandel*, Paintings, Drawings, Book-Illustrations

1955 Paris, *Galerie Furstenberg*, Paintings & Drawings

1956 London, *Matthiesen Gallery*, Paintings & Drawings

1957 Paris, *Galerie Furstenberg*, Paintings

1959 London, *Matthiesen Gallery*, Paintings, Gouaches, Drawings

1960 Amsterdam, *Stedelijk Museum*, Paintings, Gouaches, Watercolours

1961 Paris, *Galerie Karl Flimker*, Paintings, Gouaches, Watercolours, Drawings

1966 Jerusalem, *Israel Museum*, Paintings 1963–66 and Drawings 1947–1966

1967 Paris, *Galerie Claude Bernard*, Drawings 1965–66

1970 Paris, *Centre National d'Art Contemporain*, Drawings 1965–70

1972 Tel Aviv, *Gordon Gallery*, Paintings and Drawings

Los Angeles, *Los Angeles County Museum of Art*, Drawings 1965–72

New York, *Marlborough Gallery*, Drawings 1965–72

1973 Syracuse, NY, *Everson Museum*, Drawings 1965–72

Fort Worth, Texas, *Fort Worth Art Center Museum*, Drawings 1965–72

Tel Aviv, *The Tel Aviv Museum of Art*, Paintings 1957–65 & 68 (abstract period)

1974 Houston, Texas, *Janie C Lee Gallery*, Drawings and Prints

London, *Marlborough Fine Art*, Drawings & Prints

1974–79 Paris, *CNAC-MNAM-Centre Pompidou*, circulating exhibit of Prints:
1974: Boulogne-sur-Mer, *Musée des Beaux-Arts et d'Archéologie*; Saint-Quentin-en-Yvelines, *Chapelle de la Villedieu*; 1975: Le Mans, *Musée Tessé*; Nice, *Ecole Internationale d'Art Décoratif*; Dôle, *M.J.C.*; 1976: Mitry-Mory, *Municipalité*; Brive-la-Gaillarde, *Foyer Culturel*; Saint-Cloud, *M.J.C.*; Annecy, *M.J.C.*; Mandelieu-la-Napoule, *M.J.C.*; Verberie, *M.J.C.*; Bordeaux, *Renaissance du Vieux Bordeaux*; 1977: Mougins, *Maison pour Tous*; Saumur, *Bibliothèque Municipale*; Tourcoing, *Ecole des Beaux-Arts*; Vieux Condé, *Lycée Technique*; Gennevilliers, *Société Creusot-Loire*; Gérardmer, *M.J.C.*; Chamonix, *Bibliothèque Municipale*; Bastia, *Musée d'Ethnographie Corse*; 1978: Grasse, *Fédération Régionale des M.J.C.*; Sorgues, *Comité d'Animation de la Bibliothèque*; Compiègne, *Lycée Pierre d'Ailly*; Castres, *Musée Goya*; Lyon, *Espace Lyonnais d'Art Contemporain*; Myridan, *Amicale Laïque*; Evry, *Bibliothèque de l'Agora*; 1979 Cologne, *Institut Français*; Aachen, *Institut Français*; Essen, *Institut Français*; Grenoble, *Bibliothèque Municipale*;

1975 Paris, *Cabinet des Estampes, Bibliothèque Nationale*, Prints

New York, *Marlborough Gallery*, Paintings and Watercolours

1976 London, *Victoria and Albert Museum*, 'Samuel Beckett by Avigdor Arikha' – Drawings, Prints and Illustrations'

1977 Zurich, *Marlborough Gallery*, Paintings, Watercolours and Drawings

Zurich, *Galerie Amstutz*, Prints

1978 London, *Marlborough Fine Art*, Paintings, Watercolours, Drawings

1979 Houston, Texas, *Janie C.Lee Gallery*, Paintings, Watercolours and Drawings

Washington, *The Corcoran Gallery of Art*, 22 Paintings 1974–1979

Paris, *F.I.A.C. Marlborough stand*, Paintings and Watercolours

1980 Paris, *Galerie Berggruen*, Prints and Drawings

New York, *Marlborough Gallery*, Paintings, Watercolour and Drawings

1981 Dijon, *Musée des Beaux-Arts*, Paintings, Watercolours, Drawings

1982 London, *Marlborough Fine Art*, Paintings & Drawings

1983 New York, *Marlborough Gallery*, Paintings, Pastels and Drawings

1984 New York, *Marlborough Gallery*, Drawings

1985 New York, *Marlborough Gallery*, Paintings

1986 Tel Aviv, *Tel Aviv University Gallery*, Prints

London, *Marlborough Fine Art*, Paintings, Pastels and Drawings

1987 Venice, California, *L.A.Louver Gallery*, Paintings and Drawings

1988 Tokyo, *Marlborough Fine Art*, Paintings, Pastels and Drawings

New York, *Marlborough Gallery*, Paintings, Pastels and Drawings

1990 London, *Marlborough Fine Art*, Paintings, Pastels, Drawings

1992 New York, *Marlborough Gallery*, Paintings, Pastels. Drawings

1994 London, *Marlborough Fine Art*, Works 1992–93, and prints

1994 Tel Aviv, *Gordon Gallery*, Drawings

1996 New York, *Marlborough Gallery*, Recent Paintings and Drawings

New York, *Marlborough Graphics*, Selected Prints 1966–1995

1996 Tel Aviv, *Gordon Gallery*, "mahave le Avigdor Arikha", a loan exhibition, paintings, drawings, prints

1998 New York, *Marlborough Gallery*, "Sixty-five Drawings 1965-1997"

SELECTED GROUP EXHIBITIONS

1954 Milan, *10th Triennale* (awarded Gold Medal for the Rilke illustrations)

1959 Paris, *1st Biennale*

1962 Venice, *Biennale* (Israeli pavillion)

1964–6 New York, *MOMA*, *'Art Israel'* circulating exhibition in the USA and Canada

1967 Saõ Paulo, *Biennale* (Israeli pavillion)

1975–6 Los Angeles, *Los Angeles County Museum of Art* 'European Painting in the 70s'

Saint-Louis, *Art Museum* Madison, Wis. *Elvehjem Art Center*

1976 Paris, *Festival d'Automne*, 'Nouvelle Subjectivité'

1977 Paris, *MNAM-Centre Pompidou* Cabinet graphique, 'Acquisitions 1971–76'

London, *National Portrait Gallery*, New acquisitions

1978 Paris, *Cabinet des Estampes, Bibliothèque Nationale*,' L'Estampe Aujourd'hui'

Paris, *Grand Palais*, 'L'Art Moderne dans les Musées de Province'

1979 Paris, *MNAM-Centre Pompidou*, 'Oeuvres Contemporaines des Collections Nationales'

1980 Paris, *Musée des Arts Décoratifs*, 'La famille des portraits'

1981 New York, *Jewish Museum* 'Artists of Israel 1920–1980'

1982 Los Angeles, *Los Angeles County Museum of Art*, The M.& D.Blankfort Collection'

Paris, *Fondation des Arts Graphiques*, 'La lithographie en France des origines à nos jours'

Venice, *Biennale, International Pavillion* – 'Arte come arte…'

Vienna, *Museum des XXten Jahrhunderts*, 'Paris 1960–1980'

1983 Paris, Grand Palais, *'Raphaël et l'Art Français'*

1984 Washington *The Hirshhorn Museum*, 'Drawings 1974–1984'

Houston, *Janie C Lee Gallery, Master drawings 1928–1984*

London, *Marlborough Graphics* 'A Circle: Portraits and self-portraits by Arikha, Auerbach, Kitaj, Freud'

Tokyo, *Marlborough Fine Art*, 'Masters of Contemporary Figuration'

New York, *Janie C Lee Gallery*, 'Master Drawings 1879–1984'

1985 Washington, *The Hirshhorn Museum*, 'Representation Abroad'

Frankfurt, Kassel, *Kunstverein*, Wien, *Museum Moderner Kunst* 'Vom Zeichnen'

1987 Jerusalem, *Israel Museum*, Marseille, *Musée Cantini*, 'Peindre dans la lumière de la Méditerranée'

New York, *Janie C Lee Gallery*, 'Ink drawings'

1988 New York, *Janie C Lee Gallery*, 'Master Drawings 1877–1987'

1991 New York, *Janie C Lee Gallery & Kate Ganz*, 'Master Drawings 1520–1990'

Paris, *F.I.A.C. Marlborough stand* – 'Arikha, Auerbach, Bacon, Kitaj'

1993 Paris, *Musée du Louvre*, 'Copier Créer'

Madrid, *Galeria Marlborough*, 'Arikha, Auerbach, Kitaj'

London, *National Portrait Gallery*, 'The Portrait Now'

1994 Paris, *Galerie Huguette Berès*, 'Œuvres Choisies des XIX et XX siècles Peintures, dessins, sculptures'

Paris, *Galerie Marwan Hoss*, 'Figures de l'Art d'Aujourd'hui – Abakanowicz, Arikha, Auerbach, Bacon, Grooms, Kitaj, Mason, Valdes'

SELECTED BOOK-GRAPHICS
ORIGINAL LIMITED EDITIONS, PORTFOLIOS

6 Litografier till Dvärgen av Pär Lagerkvist, Sandbergs
 Bokhandel, Stockholm, 1954, 50 copies
Samuel Beckett, *L'Issue*, 6 colour aquatints, Paris, Georges
 Visat. 1968, 154 copies
Samuel Beckett, *The North*, 3 etchings, London,
 Enitharmon Press, 1972, 137 copies
Samuel Beckett, *Au Loin un Oiseau*, 5 aquatints, New
 York, Double-Elephant, 1973, 126 copies
Anne Atik, *Words in Hock*, 1 aquatint, London,
 Enitharmon Press, 1974, 30 copies
Facing Mount Zion, 7 lithographs, Tel Aviv, Gordon
 gallery, 1978, 113 copies
Anne Atik, *Offshore* 1 lithograph (and 1 by R.B.Kitaj)
 London, Enitharmon, 1991, 85 copies

SELECTED ILLUSTRATED BOOKS

Rainer Maria Rilke, *The Cornet*, hebrew translation by
 Ytzhak Shenhar, (*Massa ahavato umetato shel hakornet
 Christoph Rilke*), 35 pen drawings, (1951–52) Tarshish
 Books, Jerusalem 1953. (*Gold Medal award* of the Xth
 Triennial, Milan, 1954)
Ernest Hemingway, *The Old Man and the Sea*, Hebrew
 Hazaken vehayam, 6 pen drawings (1953) Am Oved,
 Tel Aviv, 1953
Haim Nahman Bialik, *Safiah*, (hebrew) 15 lithographs,
 and pen drawings, the Bialik Institute, Jerusalem, 1955
Nicolas Gogol, *The Dead Souls*, translated by Arthur
 Adamov, French, 13 felt drawings, La Guilde du Livre,
 Lausanne, 1956
Binyamin Tammuz, *Holot Hazahav*, Hebrew, 9 pen
 drawings, (1957) Sifriat Poalim, Tel Aviv, 1958
Samuel Beckett, *Nouvelles et Textes pour Rien*, 6 pen
 drawings, (1957) Les Editions de Minuit, Paris, 1958
S.J. Agnon, *Kelev Houtzot*, Hebrew, 5 wood-cuts (1953),
 6 pen drawings (1955) 5 brush drawings (1958),
 Tarshish Books, Jerusalem, 1961
T. Carmi, *Nahash Hanehoshet*, 6 inks (1960), Tarshish
 Books, Jerusalem, 1961

ARCHITECTURAL WORKS

Woonsocket, R.I., USA, Bnei Israel synagogue, 30 stained
 glass windows (1961)
Jerusalem, Municipality, City Council Hall, 6 stained glass
 windows (1968, installed in 1972)
Jerusalem, Beith Hahayal, one mosaic (1970)

PROJECT (UNREALIZED)

Project for An Environmental Structure (Labyrinth) to be
 erected in a park or public garden, 1971 in: *A Report on
 the Art and Technology Program of the Los Angeles
 County Museum of Art*, Los Angeles, 1971

STAGE DESIGN

Endgame by Samuel Beckett, directed by Alvin Epstein,
 The Samuel Beckett Theatre, Theatre Row, New
 York, 1984.

PUBLIC COLLECTIONS

Amsterdam: Stedelijk Museum
Boston: Museum of Fine Arts
Denver: Co., Denver Art Museum
Dijon: Musée des Beaux-Arts
Edinburgh: Scottish National Portrait Gallery
Edinburgh: Scottish National Gallery of Modern Art
Florence: Galleria degli Uffizi
Hillerød, Det Nationalhistoriske Museum på
 Frederiksborg
Houston: Museum of Fine Arts
Jerusalem: Israel Museum
Little Rock: Arkansas Arts Center
London: Tate Gallery
London: National Portrait Gallery
Los Angeles: Los Angeles County Museum of Art – The
 Blankfort Collection
Marseille: Musée Cantini
New York: Metropolitan Museum
New York: The Jewish Museum
New York: Exxon Corporation Collection
Paris: Musée du Louvre, Cabinet des Dessins
Paris: Cabinet des Estampes, Bibliothèque Nationale
Paris: Musée National d'Art Moderne, Centre Pompidou
Roanne: Musée Déchelette
San Francisco: The Fine Arts Museum – The Achenbach
 Foundation
Tel Aviv: The Tel Aviv Museum of Art
Washington: Hirshhorn Museum

PUBLIC PORTRAIT-COMMISSIONS

1982 Scottish National Portrait Gallery, Edinburgh:
 The portrait of *H. M. Queen Elizabeth The Queen
 Mother*, 1983
1988 Scottish National Portrait Gallery, Edinburgh:
 The portrait of *Alec Douglas-Home, Lord Home
 of the Hirsel*, 1988
1990 Ministère de la Culture, Paris: The portrait of
 Catherine Deneuve, 1990
1992 Scottish National Portrait Gallery, Edinburgh:
 The double portrait of *Moira Shearer and
 Ludovic Kennedy*, 1993
1997 Galleria Degli Uffizi, Florence: *Selfportrait*, 1997
1997 Det Nationalhistorike Museum på Frederiksborg,
 Hillerød: *Portrait of Herbert Pundik*

WRITINGS BY ARIKHA

BOOKS BY ARIKHA

Nicolas Poussin: The Rape of the Sabines, The Museum of
 Fine Arts Houston and the Art Museum, Princeton
 University, published by the MFA, Houston, 1982,
 68pp.
 idem: a modified version in : *Nicolas Poussin: Lettres et
 Propos sur l'Art, textes réunis et présentés par Anthony
 Blunt, avant-propos de Jacques Thuillier suivi de
 Réflexion sur Poussin par Arikha*, Collection Savoir,
 Hermann, Paris, 1989.
 idem: in *Nicolas Poussin Cartas y consideraciones en
 torno al Arte*, trad. Lydia Vázquez, Madrid, Visor, 1995,
 pp.173–207
*J.A.D.Ingres: Fifty Life Drawings from the Ingres Museum
 of Montauban*, The Museum of Fine Arts, Houston
 and the Frick Collection, New York, published by the
 MFA Houston, 1986, 120 pp.
Peinture et Regard, Écrits sur l'art 1965–1990, Hermann,
 Éditeurs des Sciences et des Arts, Collection Savoir sur
 l'art, Paris 1991, 256 pp. Second (rectified) and
 enlarged edition, (*écrits sur l'art 1965–1993*), Paris,
 1994, 268 pp.
On Depiction, selected writings on art 1965–94, Bellew
 Publishing, London, 1995, 240 pp.

ESSAYS, ARTICLES AND STATEMENTS BY ARIKHA

(titles marked with an * are reprinted (sometimes
 modified) in *Peinture et Regard*
'Bein melakha leomanuth', *Massa*, Tel Aviv, Dec. 1952,
 no22 p.2 (Hebrew)
'Kain Noak Abraham, israels nya literatur' *BLM*,
 Stockholm, vol.23 no4, April 1954,pp.289–293
 (written in German, Swedish translation by Johannes
 Edfelt)
'Kryat Hareik', *Qeshett*, Tel Aviv, 1959, vol.5,pp.80–95
 (Hebrew)
Untitled statement, in *Le Jardin des Arts*, Paris, November
 1961, vol.84, p.60
'Halal o halal ruah', *Kav*, Jerusalem 1965, vol.2 pp.22–23
 (Hebrew)
* 'Peinture et Regard', *Les Lettres Nouvelles*, Paris,
 May–June 1966, pp.75–77
Untitled statement, in *Arts Primitifs dans les Ateliers
 d'Artistes, Musée de l'Homme*, Paris 1967
'Peinture: Le Neuf ou l'Unique?', *Les Lettres Nouvelles*,
 Paris, March–April 1968, pp.144–146
'Al rishumei Ingres', *Kav*, Jerusalem, 1968, vol.8, pp.72–73
 (Hebrew)
'Samuel Beckett', *Haaretz*, Tel Aviv, 7 November 1969
 (Hebrew)
* *Two Books: The Apocalypse of Saint-Sever* and *Matisse's
 Jazz*, The Los Angeles County Museum of Art, 1972
 (exh. brochure, contains errors)
 idem: 'Beatus & Jazz' French version in *Connaissance
 des Arts*, No 468, Paris, Feb.1991,16 color .pl., pp.26–41
 idem: 'Beatus y Jazz Matisse y el Apocalipsis de San
 Severo' Spanish translation (by Letitia Leduc) in *Saber
 Ver*, Año 1, no3, Mexico-City, March 1992, 13 c.pl.,
 pp.6–22
Statement: in *European Painting in the 70s: New Work by
 16 Artists*. Los Angeles County Museum of Art, 1975
 (exh.cat.)
Statement: in *Avigdor Arikha: Paintings and Watercolours*,
 Marlborough Gallery New York 1975 (exh.cat.):
 Reprinted in German in *Avigdor Arikha: Ölbilder-
 Aquarelle-Zeichnungen*, Marlborough Galerie, Zürich,
 1977 (exh.cat.); reprinted in *Arikha: Oeuvre gravé*,
 Institut Français, Cologne, Jan–Feb.1979 (exh.
 announcement)

* 'De la Saccade au Damier', *Art International*, vol.21, no3, May–June 1977, pp.17–23

'A propos du terme Palestine' (published under the pseudonym 'A.Vigo'), *Pouvoirs*, Paris 1978, vol.7, pp.157–162

'Un livre de Samuel Beckett et Avigdor Arikha: Au loin un Oiseau. Note d'Avigdor Arikha': *La Revue de l'Art*, Paris, 1979, no 44, p.103

untitled text in *Facing Mount Zion*, Seven lithographs, The Gordon Galleries, Tel Aviv, 1978 (Hebrew and English)

* *L'Enlèvement des Sabines de Poussin*, Musée du Louvre, R.M.N., Paris 1979 (*Petit Journal* accompanying the exhibition *Dossier no 17 du Département des Peintures du Musée du Louvre, 10 mars – 21 mai 1979* curated by this author)

* *Ingres: 53 dessins sur le vif du Musée Ingres et du Musée du Louvre*, Israel Museum, Jerusalem, 1981, 180 pp. (French & Hebrew)

Ingres – Dessins sur le vif: 52 dessins du Musée Ingres de Montauban, Musée des Beaux-Arts, Dijon, 1981, 80 pp.

Untitled, in *L'Écriture et la Peinture*, CNAC Magazine, Centre Georges Pompidou, Paris, November–December 1982, pp.12–13

* 'De l'Abstraction en Peinture', *Cahiers du Musée National d'Art Moderne*, Centre Georges Pompidou, Paris 1982, vol.10, pp.208–211

* Untitled, on Pierre Bonnard, *Petit Journal Bonnard*, Musée National d'Art Moderne, Centre Georges Pompidou, Paris, 1984 (brochure)

Untitled, in *'Culture et Démocratie aujourd'hui'*, a colloquy in the French Senate, *France-Forum*, Paris, April–June 1985, vol.219–220, p.26

Untitled, in *Vom Zeichnen Aspekte der Zeichnung 1960–1985* exh.cat. Frankfurter Kunstverein, Frankfurt-am Main, 1986, p.20

* 'Pintor Real', (book review on J.Brown's Velazquez, Painter and Courtier), *The New York Review of Books*, vol.XXXIII, No 17, New York, Nov.6, 1986, pp.27–35
idem: 'Pintor Real', *Diario 16 (Culturas)* Madrid, 30 Nov. 1986, pp.II–V (Spanish translation)

Untitled, in *Art Libraries Journal*, vol.11 No 3, Preston, Great Britain, 1986, p.14

* 'A Propos de la Lumière', *Le Débat*, vol.44 , Paris, March–May 1987, pp.164–66
idem: 'On Light', *Antique*, London, Summer 1987, p.47
idem : an enlarged version in *Art in America* Jan.1988, pp.102–104 (editorial errors)
idem: 'bizkhut haor hativiy', *Kav*, Jerusalem, January 1989, pp.88–89 (Hebrew)

* 'An Offshore Glance at painting in Britain', *Art International*, no 1, Paris, Autumn 1987, pp.62–64

'The End of the History of Art?', letter, *The Times Literary Supplement*, No 4,411, London, October 16–22, 1987, p.1139

* On Peter Paul Rubens, (editorial title: 'Painter with Portfolio'), book review on C.White's Peter Paul Rubens, *The New Republic*, Washington, March 28, 1988, pp.33–37

* 'Jacques-Louis David : Les Licteurs Rapportent à Brutus les Corps de ses Fils', *Rendez-vous en France*, Dossier, no 3, Paris Dec. 1988, pp.5–8
idem: in *Connaissance des Arts*, Paris Nov. 1989, No 453, pp.72–81
idem: 'David's Brutus', English version, with an introductory note in *The Journal of Art*, vol.2 No 1, Turin, Sept.–Oct. 1989, pp.8–9 (footnotes deleted)

'An open letter to Art historians', *The Journal of Art*, vol.1 no3, Turin, February–March 1989, p.19 (editorial modifications)

* 'Giacometti's Code', *The New York Review of Books*, vol.XXXVI no 8, New York, May 18, 1989, pp.20–24

'Remarques à propos de la politique artistique', *Commentaire*, vol.49, pp.107–109, Paris, March 1990

'Un point pour le grand souffle', (on Samuel Beckett) in *Samuel Beckett, Revue d'Esthétique*, hors série 1990, pp.3–5.
idem: Hebrew version (translated by Helith Yeshurun) in *HADARIM*, vol.9, Tel-Aviv, summer 1990, pp.71–72

* 'From Prayer to Painting' published under the title of 'On Transgressing the Prohibition of Images', *The Journal of Art*, vol.3 no 3, New York, December 1990, p.32

'The Mysteries of Spanish Golden Age Drawing', a talk with Barbara Rose in *The Journal of Art*, vol.4 no 7, New York, September 1991

'Painting and the end of communism' – 'Brushes with death' (editorial title and subtitle), *The New Republic*, Washington, Dec. 16, 1991, pp.40–42
idem: Hebrew translation 'Igul hu tamid igul' in *Maariv (hashavua)*, Tel-Aviv, 17.1.1992, pp.54–55
idem: French version 'De l'Utopie avant-gardiste' in *Connaissance des Arts*, Paris, April 1993

* 'Quelle Modernité ?', *Commentaire*, no.63, Paris, autumn 1993, pp.617–622
idem, shortened English version (translated by Noga Arikha) 'What Modernity?' in *Modern Painters*, London, Summer 1994, pp.54–56 (reprinted in Peinture et Regard, second edition, 1994)

'De la boîte, des figurines et du mannequin' in *Nicolas Poussin 1594–1665*, exhibition catalogue, Galeries Nationales du Grand Palais, 27 septembre 1994–2 janvier 1995, R.M.N., Paris, 1994, pp.44–47

* 'Note à propos du *Calvaire* de Mantegna', in *Hommage à Michel Laclotte, Etudes sur la Peinture du Moyen Age et de la Renaissance*, Réunion des Musées Nationaux, Paris-Electa, Milan, 1994, p.251–259 (captions for illustrations 249–250 inverted, perspective-drawing replaced by an arbitrary detail…); published in a shorter English version in *On Depiction*

'La Lumière du Musée' in *Les Musées et la Lumière*, Musée du Louvre, série 'Musées-musées', Paris, 1995, brochure, p.13

'Consideraciones sobre la idea de obra maestra en la pintura occidental' in *Obras Maestras del Museo del Prado*, Madrid, Electa-Fundacion Amigos del Museo del Prado, 1996, pp.9–15 (trans.from the English original by Maria-Luisa Balsero)

'Visión falseada en el Prado: la Extinción de la Pintura', *El Pais*, Madrid, 11 Jan. 1997, Babelia, p.19 (originally written in French)
idem: 'L'extinction de la peinture', *Le Monde*, Paris, 15 March 1997
idem: 'Let in daylight on the magic of art' (editorial title), *The Times*, London, May 24 1997, p.22

'Sobre fragmentos y bordes' in *Museo del Prado – Fragmentos y detalles*, Fundación dos Amigos del Museo del Prado, Madrid, 1997, pp.163–173, trans. From the Engl. by Maria Luisa Balseiro

CURATORSHIPS

1979 Paris, Musée du Louvre: *L'Enlèvement des Sabines de Poussin*

1981 Jerusalem, Israel Museum: *52 Dessins sur le Vif du Musée du Louvre du Musée Ingres*

1981 Dijon, Musée des Beaux-Arts: *Ingres, Dessins sur le Vif*

1983 Houston, The Museum of Fine Arts: *The Rape of the Sabines by Poussin*

1983 Princeton University, The Art Museum: *The Rape of the Sabines by Poussin*

1986 Houston, The Museum of Fine Arts: *Ingres Fifty Life Drawings*

1986 New York, The Frick Collection: *Ingres Fifty Life Drawings*

SELECTED INTERVIEWS

BARZEL, Amnon: 'Sihot im Avigdor Arikha', *Haaretz*, Tel Aviv, 18 Feb. 1972 (Hebrew)

BARZEL, Amnon: 'Hakmihah Letzayer min Hateva', *Haaretz*, Tel Aviv, 5 Sep. 1975 (Hebrew)

BOWLES, Patrick: 'Avigdor Arikha – An Interview and Portfolio presented by Patrick Bowles' *The Paris Review*, vol.33, Winter–Spring 1965, pp.22–29

JODIDIO, Philip: '3 Opinions sur la situation Culturelle en France: 1. Avigdor Arikha' *Connaissance des Arts*, No 427, Paris, September 1987, pp.58–61 (erroneous biographical data)

MAURIES, Patrick: 'Sur le Vif' *L'Âne le Magazine Freudien*, no26 Paris, April–June 1986, pp.14–15

ROSE, Barbara: *Avigdor Arikha interviewed by Barbara Rose* exhibition catalogue, Avigdor Arikha Oil Paintings, Watercolours, Drawings Marlborough Fine Art, London, May–June 1978; reprinted in Avigdor Arikha Drawings Watercolors and Paintings, Janie C. Lee Gallery, Houston, Texas, February–March 1979

SAHUT, Marie-Catherine: 'L'Enlèvement des Sabines de Poussin', interview, *La Revue du Louvre*, Paris 1979, no2, p.142

SELDIS, Henry J.: 'A Conversation with Avigdor Arikha', *Arts Magazine*, New York, 1975, vol.50, no 2 , pp.53–56

SHANNON, Joseph: 'An Interview with Avigdor Arikha', *Arts*, New York, Jan.1984, pp.130–133

TUCHMAN, Maurice: 'A Talk with Avigdor Arikha', *Art International*, May–June 1977, vol.21, no3, pp.12–16

VIATTE, Germain: *Avigdor Arikha – Germain Viatte: extrait d'un entretien (20 juillet 1973)*, travelling exhibition brochure Arikha 39 Gravures, Centre National d'Art Contemporain, Paris, 1973

SELECTED LECTURES AND TALKS

RADIO

A talk on the Collection of the São Paulo Museum BBC Hebrew Service, London, July 1954, (7')

An interview with Daniel Le Comte, Radio France, France Culture, Paris 22 Oct 1976 (27')

An interview with Connie Goldman National Public Radio, Washington D.C. 19 July 1979 (12')

An interview with Amnon Ahineomi , Kol Israel, Jerusalem 6 July 1980 (one hour)

Nicolas Poussin – a joint talk with Pierre Rosenberg's – interviewers: Pierre Descargues, Radio France France Culture, 11 Feb 1982 (26')

On Antoine Watteau – interview with Pierre Descargues, France Culture, 12 Nov 1984 (12')

An interview produced by Sam Collyns and Adrian Velicu BBC Radio 3 'New Premises'(series V), London, 7 Dec 1986 (15') (contains inaccuracies)

Zeitzeichen – on Henri Cartier-Bresson West Deutscher Rundfunk 2, 22 Aug 1988 (German, 7' within 15' (German)

An interview with Richard Thomson, 'Third Ear', produced by Judith Bumpus, BBC RADIO 3, 7 Apr 1989 (26')

On Sumerian art – Participation in *'Emission spéciale Grand Louvre'* France Culture, Paris, April 1, 1989

TELEVISION & FILM

An interview with Terry Wehn-Damish 'Zigzag' Télévision Française ANTENNE 2 Paris, 28 Oct 1976, (10')

On Chardin, (shared with Pierre Rosenberg) 'Zigzag' ANTENNE 2, Paris (?) Feb 1979 (7' within 26')

On Poussin's 'l'Enlèvement des Sabines', Télévision Belge, (?) Apr.1979

Le portrait 'Zigzag' ANTENNE 2, Paris, 30 Jan 1980 (7' within 26')

On *Monsieur Bertin by Ingres* Télévision Française TF1, within the televised news broadcast, Paris, (?) Aug.1980 (5')

A brief interview about the portrait of H.M. Queen Elizabeth, The Queen Mother, Breakfast News, BBC1, ITV, and STV, London and Edinburgh 4 Aug.1983

'Du vif au vrai' a film directed by Daniel Le Comte, Télévision Française TF1, Paris, 12 Apr 1985 (26')

On Henri Cartier-Bresson, Indian National Television, New Delhi, 1985, (date?)

A short talk within the televised news, *televisia limudit*, Tel-Aviv, Jan.(?)1986 (7', Hebrew)

Five short films : *Velàzquez'Meninas* (9'); *Poussin's Deluge* (8'); *David's Brutus* (11'); *Caravaggio's Saint Andrew* (12'); *Vermeer's Woman Holding a Balance* (15'); Directed and produced by Sarah Stein, (sponsored by *Minda de Gunzburg, The ASDA Foundation*), New York, 1985. First shown at the *Musée du Louvre*, Paris: *David's 'Brutus'*, 15 Jan. 1990, the other four 5 Feb. 1990

An interview with Robert Hughes in *Saturday Review*, directed by Rosemary Bowen-Jones, BBC2, 8 March 1986

Das Hungrige Auge: Avigdor Arikha, a film by Erwin Leiser, (60'), German television networks, first broadcast: 2 Sep. 1991 (SWF, SF, *Saarländischer Rundfunk* (German and English versions).

Avigdor Arikha on Diego Velazquez, a film directed by Patricia Wheatley, produced by Keith Alexander ('Artists Journeys' BBC *Music and Arts*, prod. 1992, 40'), first shown: London, BBC2 24 May 1992. Shown at the *Louvre*, Paris, 25 April 1994

Avigdor Arikha, a film ('*Omnibus*') directed by Patricia Wheatley, BBC1 (50') first broadcast: London, 27 October 1992; first broadcast on Israel Television on 18 October 1992.

LECTURES

Drawing tools and techniques, courses given to the curators of the *Cabinet des Dessins, Musée du Louvre*, Paris, 1971

Peindre Aujourd'hui a lecture, Ecole Nationale Supérieure des Beaux-Arts, Paris, 16 Dec. 1981

On Poussin's Deluge, a seminar, Department of Art History, Université de Genève, Geneva, 4 June 1982

Nicolas Poussin and the Classical Ideal Museum of Fine Arts, Houston, Texas. 24 Jan 1983

Some late works of Nicolas Poussin, Princeton University, The Art Museum, (McCormick Hall), Princeton, NJ, 1 May 1985

A propos de Deux Pastels de Degas (Portraits d'Amis sur Scène, 1879, Baigneuse allongée sur le Sol, 1886–8), Musée d'Orsay (part of the series 'Voir et Apprendre à Voir'), Paris, 30 October 1988

An informal seminar and a Public lecture on '*disruptures in styles*', The Graduate School of Fine Arts, University of Pennsylvania, Philadelphia, 14 and 15 Feb.1989

Disruptures in style – painting today, School of Art, Yale University, New Haven, 20 Feb 1989

Prix des Arts des Lettres et des Sciences – Fondation du Judaïsme français,the laureat's lecture, Paris, 25 May 1989

On David's 'Brutus' and his 'unfinished' portraits, Bretey Memorial Lecture, University of Manchester, Manchester, May 17, 1990

L'Oeuvre en direct: L'Enlèvement des Sabines de Nicolas Poussin, a discussion shared with Pierre Rosenberg at the Louvre and Keith Christiansen at the Metropolitan Museum, New York, via Satelite, *Auditorium du Louvre* and *Auditorium of the Metropolitan Museum of Art*, Paris, 18 February 1994

Les musées et la lumière, Musée du Louvre, Auditorium, (debate), Paris, 25 January 1995

Considerations of the Notion of Masterpiece in Western Painting, inaugural lecture of the series *Obras maestras del Museo del Prado*, Madrid, Museo del Prado, Sala Juan de Villanueva, 17 Oct. 1995

On fragments and edges, a lecture, Madrid, Museu del Prado, Sala Juan de Villanueva, 10 December 1996

EXHIBITION CATALOGUES
(in chronological order)

ARTISTS' HOUSE JERUSALEM, 5–24 Jan.1953, *Paintings, Drawings, Illustrations* foreword by Binyamin Tammuz, Hebrew & English, brochure 8p.

NATIONAL BEZALEL MUSEUM, Jerusalem, 5–22 Sep. 1953, *Peintures, Dessins, Bois*, foreword by Mordechai Narkiss, Hebrew & French, folder

GALERIE MODERNE, Stockholm, 24 Apr–7 May 1954, checklist, Swedish, folder

ATHENÆUM KUNSTHANDEL, Copenhagen, 1–15 Sep. 1955, *tegninger, grafik og bogkunst* introduction Peter P. Rohde, Danish, folder, 1 repr.(cover)

MATTHIESEN GALLERY, London, Apr. 5–28, *first London exhibition* 1956, folder

GALERIE FURSTENBERG, Paris, 2–16 Apr. 1957, *peintures récentes* text by Jean Wahl, folder

MATTHIESEN GALLERY, London, Apr. 8–May 2, 1959, *paintings, gouaches, drawings*, with a poem (French) by Samuel Beckett, brochure, 8p.1col.repr.cover

STEDELIJK MUSEUM, Amsterdam, Oct–Nov. 1960, catalogue no 248 (joint with Panter), Dutch, brochure 12pp. 7 b&w 1col. repr.

GALERIE KARL FLINKER, Paris, 11 Oct–4 Nov. 1961, untitled brochure 1 col.(cover) 2 bl&w repr.

ISRAEL MUSEUM, Jerusalem, *Paintings 1963–66 drawings 1947–1966* Sep.–Oct. 1966, introduction Yona Fischer. Hebrew & English, brochure, 12pp. 4 b&w repr.

GALERIE CLAUDE BERNARD, Paris,Jan.–Feb. 1967, *Arikha – dessins*, announcement, with the text 'Pour Avigdor Arikha' by Samuel Beckett

CENTRE NATIONAL D'ART CONTEMPORAIN, Paris, *Dessins 1965–1970* 8 Dec. 1970–18 Jan.1971, foreword Samuel Beckett, introduction Barbara Rose, two texts by the artist, 64 pp. 42 repr. Supplementary checklist 8pp.

LOS ANGELES COUNTY MUSEUM OF ART, *39 Ink drawings* Apr. 25–May 28, 1972 (extended to July 31), with a text by Samuel Beckett introduction Barbara Rose and a presentation note by Maurice Tuchman, folder 1rep.(cover)

MARLBOROUGH GALLERY, New York, *ink drawings 1965–1972*, Dec. 1972, foreword Samuel Beckett, introduction Barbara Rose, 8p. folder 1 repr.

FORT WORTH ART CENTER MUSEUM, *idem.* Apr–May 1973

CENTRE NATIONAL D'ART CONTEMPORAIN (later MNAM-Centre Pompidou), Paris 1973, *39 gravures 1970–73*, travelling exhibition catalogue, (later increased number of prints) 1974–1979, 28 cities in France and 3 in Germany, introduction André Fermigier, and an interview with Germain Viatte, brochure, 8p. 40 repr.(vignette)

THE TEL AVIV MUSEUM OF ART, March–Apr.1973, *paintings:1957–1965 & 1968* (retrospective of the abstract period), introduction by Haim Gamzu brochure, 28pp. 12 b&w repr. Hebrew & English

MARLBOROUGH FINE ART, London, March 1974, *Drawings, Inks and Etchings*. introduction by Robert Hughes, 30 pp. 64 repr. (mostly vignette)

MARLBOROUGH GALLERY, New York, Oct.11–Nov.1, 1975 *paintings and watercolors 1973–1975* (first show of the life-paintings) with a text by the artist, 24pp. 13 b&w repr. 6 col.

VICTORIA & ALBERT MUSEUM, H.M.S.O., London, 11 Feb.– 23 May 1976, *Samuel Beckett by Avigdor Arikha*, foreword C.M. Kauffmann, introduction and catalogue Mordechai Omer, brochure, 12pp. 16 repr.

MARLBOROUGH GALERIE AG, Zürich, Apr–May 1977, *Ölbilder, Aquarelle, Zeichnungen* foreword by Samuel Beckett , 20pp. 9 b&w 2 col.repr.

ATELIER CROMMELYNCK, *Avigdor Arikha Huit Gravures*, Paris 1977, eight collotype reproductions, edition of 500 copies

GALERIE AMSTUTZ, Zürich, autumn 1977, *Huit gravures – Éditions de l'Atelier Crommelynck, Paris*, brochure,12pp. 8epr.

MARLBOROUGH FINE ART, London, May–June 1978, *Oil-paintings – Watercolours-Drawings*, interview with Barbara Rose, 20 pp. 9 b&w 6 col.repr.

NEW 57 GALLERY, Edinburgh, Festival Exhibition, Aug. 14–Sep.9, 1978 *Paintings Drawings Watercolors*, foreword by Samuel Beckett, 16pp. 9 b&w 3 col.repr.

JANIE C. LEE GALLERY, Houston, Texas, Feb–March 1979, *drawings, watercolors and paintings*, introduction: interview with Barbara Rose, brochure, 16pp. 5col 2 b&w repr.

THE CORCORAN GALLERY OF ART, Washington, D.C., June 15– Aug.26, 1979 *Twenty Two Paintings 1974–78*, introduction by Jane Livingston, 40pp. 18 b&w 4 col.repr.

MARLBOROUGH GALLERY, New York, Oct. 4–Nov.1, 1980 *recent work*, 44pp. 5 col. 32 b&w repr.

BERGGRUEN, Paris, 29 May–12 Sep, *dessins et gravures*, with a text by the artist, 98pp. 80 repr.

MUSÉE DES BEAUX ARTS DE DIJON, 29 March–28 June 1981, *Arikha* introduction by Pierre Georgel, 60 pp. 107 b&w repr. (mostly vignette)

MARLBOROUGH FINE ART, London, May–June 1982, *oil paintings and drawings* 48pp. 9 col. 33 b&w repr.

MARLBOROUGH GALLERY, New York, Sep.8–Oct.4, 1983, *paintings, drawings and pastels*, 14 col. 28 b&w repr.

MARLBOROUGH GALLERY, New York, Nov.8–Dec.4, 1984, *New York drawings* January–May 1984, introduction Jane Livingston, 36pp. 36 repr.

MARLBOROUGH GALLERY, New York, May 29–June 22, 1985, *recent paintings* 30 pp. 15 col. 10 b&w repr.

TEL AVIV UNIVERSITY GALLERY, Jan–Feb. 1986, *prints 1950–1985*, introduction by Mordechai Omer, reprint of 1974 Robert Hughes introduction, and of 'Avigdor Arikha interviewed by Barbara Rose'. (Many errors – second corrected limited reprint) 144 pp. 110 repr.

MARLBOROUGH FINE ART, London, October 1986, *oil paintings, pastels and drawings*, 48pp. 18 col. 25 b&w repr.

L.A. LOUVER, Venice California, Apr.7–May 9, 1987,with excerpts from texts by Samuel Beckett, Robert Hughes, Barbara Rose, Maurice Tuchman, (faulty exhibitions-list and bibliography, two pages errata were printed later) 32pp. 13 col. 8 b&w repr.

MARLBOROUGH FINE ART LTD TOKYO, Apr. 19 – May 31, 1988, *oils, Watercolours, pastels, inks and drawings*, introduction by Shûji Takashina, 50pp. 25 col. 7 b&w repr. Japanese & English

MARLBOROUGH GALLERY, New York, October 1988, *paintings, pastels and drawings 1986–1988* , with a text by the artist, 48pp. 29col. 10 b&w repr.

MARLBOROUGH FINE ART, London, 14 March – 14 April 1990, *oils, pastels, drawings*, 56 pp. 31 col. & 16 b&w repr.

MARLBOROUGH GALLERY, New York, May 7–June 6, 1992, *Works 1990–91*, 44pp. 28 col. 8 b&w repr.+cover

MARLBOROUGH FINE ART, London, 6 May–4 June 1994, *Works 1992–1993*, 40 pp. 27 col.pl

MARLBOROUGH GRAPHICS, London, 6 May–June 1994, *Etchings & Lithographs*, 24 pp. 20 pl.

GORDON GALLERY, Tel Aviv, 25 May–14 June, 1994, *Drawings*, 56 pp., 40 bl. pl., Hebrew

MARLBOROUGH GALLERY, New York, 14 May–15 June 1996, *Recent Paintings and Drawings*, 44 pp. 29 col. pl. 9 b&w pl.

MARLBOROUGH GRAPHICS, New York, 14 May–15 June 1996, *Selected Prints 1966–95*, 38pp. 65 pl.

MARLBOROUGH GALLERY–GRAPHICS, New York, 4 March–31 March 1998, Sixty-five Drawings 1965–1997, 56 pp. 65 pl.

PUBLICATIONS ABOUT ARIKHA

BOOKS-MONOGRAPHS

ARIKHA – texts by Samuel Beckett, Richard Channin, André Fermigier, Robert Hughes, Jane Livingston, Barbara Rose. Interviews by Barbara Rose, Joseph Shannon and Maurice Tuchman. 224 pp. 106 col.pl. 83 b.& w., *Hermann*, Paris / *Thames and Hudson*, London, 1985.

ARIKHA, by Duncan Thomson, 256 pp. 216 pl, most in colour, *Phaidon*, London, 1994. Second printing, paperback, 1996

LIMITED ORIGINAL EDITION:

Avigdor Arikha: Boyhood Drawings made in Deportation – Seven facsimile reproductions of drawings made at age thirteen in Nazi concentration camps (1942–43) with an introduction, 18 pp.box, English edition of 200 copies, French edition of 100 copies all signed and numbered. Printed in collotype by *Daniel Jacomet*, Paris, 1971, published by Alix de Rothschild for the benefit of Youth Aliyah.

SELECTED ESSAYS, ARTICLES & REVIEWS ABOUT ARIKHA

[Anonymous] 'Mr Avigdor Arikha, a brilliant young painter' *The Times*, London, 27 April 1956

ANDREAE, Christopher: 'Images that Obey the Eye' in *The Christian Science Mintor*, Boston, pp.16–17 3 col.repr.

ANDRAI, Jean-Louis: 'Comprendre Arikha' in *Connaissance des Arts*, Paris, Sep. 1994, p.29

ASHBERY, John: 'Paris Notes' *Art International*, vol.V/9 1961, p.50

BECKETT, Samuel: *Pour Avigdor Arikha*, 1966, Galerie Claude Bernard, Paris Jan–Feb. 1967, exh.announcement. German translation (by Elmar Tophoven) in *Samuel Beckett Auswahl*, Suhrkamp Hausbuch, Frankfurt-am Main, 1967, p.379 Reprinted in *Avigdor Arikha Dessins 1965–1970*, Centre National d'Art Contemporain, Paris 1970, English version: in *Arikha 39 Ink Drawings 1965–1972* Los Angeles County Museum of Art, April–June 1972, Marlborough Gallery New York, 1972. Fort Worth Art Center Museum, 1973; French and English versions reprinted in *Samuel Beckett by Avigdor Arikha*, Victoria and Albert Museum, London,1976; *Avigdor Arikha –Ölbilder, Aquareelle, Zeichnungen* German translation Marlborough Galerie AG, Zürich, 1977, *Avigdor Arikha – Paintings Drawings Watercolors* New 57 Gallery, Edinburgh, 1978. Samuel Beckett *Disjecta*, Calder, London, 1983 p.152

BECKETT, Samuel: *CEILING* 'for A.A.' in *Arikha*, Paris-London, 1985; French version *PLAFOND*, reprinted : 'En Attendant Arikha', in *Le Nouvel Observateur*, Paris, 18–24 October 1985, pp.102–103

BECKETT, Samuel: untitled, in *Arikha*, Paris-London, 1985; reprinted in *Lire*, Paris, February 1990, p.21

BERRYMAN, Larry: 'Avigdor Arikha – Marlborough Fine Art', *Arts Review*, vol.XXXVIII, No 21, London, 24 Oct 1986, p.579

BERRYMAN, Larry: 'Avigdor Arikha', *Arts Review*, XLII, No 7, London, 6 April 1990, pp.182–83

BOSQUET, Alain: 'The Illustrations of Avigdor Arikha', *Typographica*, No 15, London, 1957, pp.22–29

BRENSON, Michael: 'A World of Menace from Avigdor Arikha', *The New York Times*, 16 Sep 1983

BRENSON, Michael: 'When Royalty called Arikha', *The New York Times*, 23 Sept 1983

BRENSON, Michael: 'Fresh Vision Based on a Grand Tradition' *The New York Times*, 7 July 1985

BRONOWSKI, Yoram: 'Pegisha im Avigdor Arikha' *Haaretz*, Tel Aviv, 30 Aug. 1991 (Hebrew)

BUTCHER, G.M.: 'What I tried to think was impossible' *Art News and Review*, London 9 May 1959

CABANNE, Pierre: 'Arikha au bout du miroir', *Combat*, Paris, 14 Dec 1970

CABANNE, Pierre: 'Arikha en Noir et Blanc', *Le Matin* , Paris, 8 Aug 1980

CALVO SERRALLER, Francisco: 'La mirada oblicia', *El Pais*, Madrid, 9 Jul. 1994

CASSOU, Jean: introduction to Arikha, *8 Lithographies sur le thème de Cain*, Caractères, Paris 1955 original edition

CLAIR, Jean: 'Arikha', *l'Express*, Paris, 20–26 Feb. 1987, p.107

CLOTHIER, Peter: 'Avigdor Arikha', *Art News*, New York, September 1987, p.155

COMTE, Philippe: review, in *Opus International* no 23,, Paris, March 1971, p.54

CORCOS, Pierre: 'Le Regard Devant les Mots' in *Opus*, no 126, Paris 1991

CORDELLIER, Dominique:in *Raphaël et l'Art Français*, R.M.N.Grand Palais, Paris 1983, pp.71–72

COTTER, Holland: 'Avigdor Arikha at Marlborough', *Art in America*, New York, March 1989, pp.144–45

CUZIN, Jean-Pierre: 'Tendresse et Colère', *Connaissance des Arts*, Paris, October 1988, no 440, pp.106–114, 9 col. repr.+ cover photograph by Hans Namuth

CUZIN, Jean-Pierre, and Marie-Anne DUPUY, in *Copier Créer*, exhibition catalogue, Musée du Louvre, Paris, 1993, pp.194–195

DEJEAN, Philippe: 'Avigdor Arikha: le hasard et la nécessité', *Le Quotidien de Paris*, 8 Aug 1980

DICKSON, E.Jane: 'Truth Games', *The Independent Magazine*, London, 7 May 1994, pp.24–30 10 col. repr. + cover, photograph by Henri Cartier-Bresson

EDELMAN, Robert G.: 'Avigdor Arikha at Marlborough', *Art in America*, New York, December 1985, pp.129–130

FEALDMAN, Barry: 'A Major Painter of our Time', *The Jewish Chronicle*, London, 18 June 1982

FERMIGIER, André: introduction, travelling exhibition catalogue *Arikha 39 Gravures 1970–1973*, Centre National d'Art Contemporain, Paris, 1973

FERMIGIER, André: 'Arikha à Zurich', *Le Monde*, Paris, 12 May 1977

FERMIGIER, André: 'La Bataille de Bédriac', *Le Monde*, Paris, 12 June 1980

FERMIGIER. André: 'La Minute de Vérité' *Le Monde*, Paris, 5 June 1982

FIRTH, Jack: 'He Accepted the Challenge', *Books in Scotland*, October 1994

FISCHER, Yona: *Landscape-Abstraction-Nature*, The Israel Museum, Jerusalem, 1972, pp.70, 110–112

FISCHER, Yona: *Masterpieces of The Israel Museum*, Florence, 1985, p.65

FISCHER, Yona: in *Peindre dans la lumière de la Méditerranée*, exh.cat.Israel Museum, Jerusalem & Musée Cantini, Marseille, 1987, pp.202–203

FOOT, M.R.D.: 'When words stop', *Books and Bookmen*, London, April 1986

FORGEY, Benjamin : 'The Lonely Intensity of Avigdor Arikha Glows at Corcoran Exhibit' *The Washington Star*, Washington 17 June 1979

FORGEY, Benjamin : ' The Hirshhorn's Big Draw', *The Washington Post*, 15 March 1984

FOUCART, Bruno: 'Arikha au Musée des Beaux-Arts de Dijon – La Leçon de Peinture' *Le Monde*, Paris, 12 June 1981

FRÉMON, Jean: 'Arikha, Une Frémissante Lucidité', *Politique-Hebdo*, Paris, 31 Dec 1970

GABRIEL, Nicole: 'Evening Attributes', in *La Cause Freudienne revue de psychanalyse*, no 30, Paris, May 1995, painting repr. on cover, commentary p.2

GAGE, Edward: 'Innately Honest Vision of Arikha' *The Scotsman*, Edinburgh, 31 Aug 1978

GALY-CARLES, Henri: 'Arikha', *Aujourd'hui* No 34, Paris, December 1961, p.42

GAMZU, Haim: introduction, *Avigdor Arikha, paintings:1957–1965 & 1968*, The Tel-Aviv Museum, 1973

GEORGEL, Pierre: introduction to *Arikha*, Musée des Beaux-Arts, Dijon, 1981

GETTINGS, Frank:*Drawings 1974–1984*, Hirshhorn Museum, Washington, 1984, pp.18, 30–37

GLABERSON, Barbara: 'Arikha's Classicism' *Art World*, New York,, Oct 1983

GORDON SMITH, W: 'Face Values' *Scotland on Sunday*, Edinburgh, 19 June 1994

GOSLING, Nigel: 'Artist in the Wrong Role?', *The Observer*, London, 24 Feb 1974

HENRI, Gerrit:'Avigdor Arikha at Marlborough', *Art in America*, New York, March 1981, pp.129–130

HICKS, Alistair: 'Dark Areas', *The Spectator*, London, 4 Oct 1986

HICKS, Alistair: 'Contrasting Rebels', *Antique International* vol.9, No 2, 1994, p. 739–40

HOFSTADTER, Dan: 'A Painting Dervish' (Profiles) *The New Yorker*, New York, June 1, 1987, pp.57–56; idem: slightly revised in: *Temperaments – Artists Facing their work*, Knopf, New York 1992, pp.94–122

HOFSTADTER, Dan: 'Ingres in New York',*The New Criterion*, Vol.5, no 5 January 1987, pp.17–21

HOLMES, Anne: 'Artist Gives up Abstraction for Existential Realism', *Houston Chronicle*, 26 Dec 1974

HUGHES, Robert: 'Feedback from Life', *Time*, 7 May 1973, p.38

HUGHES, Robert: introduction to *Avigdor Arikha: Inks, Drawings, and Etchings*. Marlborough Fine Art, London, 1974

HUGHES, Robert: 'Arikha's Elliptical Intensity' *Time*, 30 July 1979, p.71

HUGHES, Robert: *The Shock of the New*, New York, 1980, pp.404–405

HUGHES, Robert: 'Lost Among the Figures' *Time*, May 31, 1982 (only mentioned)

HYMAN, James: 'Avigdor Arikha no frugal meal' *Galleries Magazine*, London, May 1994

JAFFE, M.C.L.: 'Arikha', *Quadrum*, vol.9, Brussels, 1960, pp.144–45

JOHNSON, Patricia:' Works by two artists with sharply contrasting visions', *Houston Chronicle*, Sunday May 18, 1986

JOUFFROY, Alain: 'Arikha' *Arts*, Paris, 12 Oct 1955

KIMMELMAN, Michael: 'Shapes That Just Happen to Be Objects', *The New York Times*, C21, New York, May 31, 1996

KINMONTH, Patrick: 'Arikha: A Poetic Artist', *Vogue*, London, October, 1986

KITAJ, R.B.: 'Arikha', *RA – The Magazine for the Friends of the Royal Academy*, no 12, London, Autumn 1986, p.41

KRAMER, Hilton: Untitled review, *The New York Times*, 21 Dec 1972

LEISER, Erwin,'Die Eroberung der Wirklichkeit' *DU*, Zürich, June, 1987, pp 80–85.

LIVINGSTON, Jane: *Thoughts on Avigdor Arikha*, introduction, The Corcoran Gallery of Art, Washington, 1979

LIVINGSTON, Jane: introduction, *Arikha, New York Drawings*, Marlborough Gallery, New York, 1984.

LIVINGSTONE, Marco: 'Arikha' *The Burlington Magazine*, London, Oct. 1986, No 1003, vol.CXXVIII, pp.757–758

LUBBOCK, Tom: 'Avigdor Arikha: Was Here', *Modern Painters*, London, Summer 1994, pp.28–30

LUCIE-SMITH, Edward: 'Avigdor Arikha', *Art and Artists*, London, May 1982, pp.36–37

MCCORQUODALE, Charles: 'Samuel Beckett by Avigdor Arikha', *Art International*, vol.XX 4–5, April–May 1976, pp.41–42

MCCORQUODALE, Charles: 'Avigdor Arikha – a Tribute to Samuel Beckett', *The Connoisseur*, London, May 1976

MAUBERT, Frank: 'Arikha', *Femme*, Paris, no 10, Nov. 1985, p.26

MAOR, Haïm: 'philosoph o poel' *Al Hamishmar*, Tel Aviv, July 29, 1994 (Hebrew)

MAURIES, Patrick: 'Avigdor Arikha, textes et interviews' *Libération*, Paris, 13 Dec. 1985

MELOT, Michel; BOURET, Claude; BOURET, Blandine: *La Lithographie en France des Origines à Nos Jours*, Fondation Nationale des Arts Graphiques et Plastiques, Paris, 1982, pp.207, 234

MICHEL, Jacques: 'Arikha, le Retour au Dessein Réaliste', *Le Monde*, Paris, 6 Jan. 1971

MICHEL, Jacques: 'Des Peintres qui peignent', *Le Monde*, Paris, 4 November 1976

MITCHELL, Breon: *Beyond Illustration: The Livre d'Artiste in the Twentieth Century*, The Lilly Library, Indiana University, Bloomington, 1976, pp.53, 72 83

MUCHNIC, Suzanne: 'His Passion: Painting from Life', *Los Angeles Times*, Calendar, Apr 9, 1987, part VI, pp.1 & 4

NAGEL, C.U.: 'Radierungen von Arikha in Institut Français' *Aachener Volkszeitung*, Aachen, 14 Feb 1979

NARKISS, Mordecai: announcement preface *Avigdor Arikha –Peintures, Dessins, Bois*, Le Musée National Bézalel, Jerusalem, 1953

NEWS: The National Galleries of Scotland News, Edinburgh, Sep–Oct 1983

OMER, Mordechai: introduction *Samuel Beckett by Avigdor Arikha*, Victoria and Albert Museum, London 1976.

OMER, Mordechai: 'Avigdor Arikha: Face to Face towards life and Still Life' introduction to *Avigdor Arikha, Prints 1950–1985*, The University Gallery, Tel Aviv University, 1986 (Hebrew & English)

OMER, Mordechai, 'The scream as reflected in Beckett and Arikha' *Motar 1*, Tel Aviv University, 1993, pp.26–31 (Hebrew)

OTT, Günther: 'Beckett mit Weinglass, Ausstellung im französichen Institut', *Kölnische Rundschau*, Cologne, 7 January 1979

PEPPIATT, Michael: 'Fièvre Oeil-main', *Connaissance des Arts*, Paris, May 1982, pp.62–69

PEPPIATT, Michael: 'Avigdor Arikha: A Hunger in the Eye', *Art International*, vol.XXV/7–8, September–October 1982, pp.18–28

PERRY-LEHMANN, Meira: *One Hundred Works on Paper from the collection of The Israel Museum*, Geneva, 1986, pp.140–141

PICARD, Denis: 'Regards avec Arikha', *Connaissance des Arts*, Paris, October 1985

QUANTRILL, Malcolm: 'London Letter', *Art International* vol.XXI/5–6, 1978, pp50–51

ROETHLISBERGER, Marcel: 'Arikha écrits sur l'art' *Connaissance des Arts*, Paris May 1992, pp.62–67

ROHDE, Peter P.: brochure preface, *Avigdor Arikha: Tegninger, Grafic og Bogkunst*, Athenaeum Kunsthandel, Copenhagen 1955

RONNEN, Meir: 'Voices of Silence', *Art News*, New York, Nov. 1979, pp.152–153

ROSE, Barbara: catalogue introduction *Avigdor Arikha Dessins 1965–1970*, Centre National d'Art Contemporain, Paris, Dec.1970–Jan.71. Revised version: *'Inks by Arikha'* Introduction, *Arikha: 39 Ink drawings 1965–1972*, Los Angeles County Museum of art 1972; Marlborough Gallery, New York, 1972; Fort Worth Art Center Museum, 1973

ROSE, Barbara: review, in *New York Magazine*, Jan.1, 1973

ROSE, Barbara: 'Talking about Art: Washington DC as Capital of Art', *Vogue*, New York, August 1979

ROUVE, Pierre: 'Startling Confluence' *Art News and Review*, vol. VIII no 6, London, Apr.14, 1956

RUGOFF, Ralph: 'Art-pick of the week' *L.A. Weekly*, Los Angeles, Apr 13–17, 1987

RUSSELL, John: 'Avigdor Arikha', review, *The New York Times*, Oct 14, 1988

SALMONA, Ygal: 'Avigdor Arikha's 'Going Out', *The Israel Museum Journal*, Jerusalem, 1984, vol.III, pp.85–86

SCHIPPERS, K: 'De onbetrouwbare wandelstok' *NRC Handelsblad* Cultureel supplement, Amsterdam, August 5. 1994 (full page, four colour reproductions, Dutch)

SHEFFY, Smadar: 'Zot rak mahshava al ham'tziut' *Haaretz*, Tel Aviv, 1 June 1994

SCHIFF, Fritz: 'Avigdor Arikha veomanuto shel dor hadash'. *Mevooth*, Tel Aviv, Nov 1953 (Hebrew)

SELDIS, Henry J: 'Works by Arikha Painter and Scholar on Display' *The Los Angeles Times* (Calendar) May 21, 1972

SELDIS, Henry J: 'European Art Filling in the Gap', *The Los Angeles Times* (Calendar) Oct.12, 1975

SHANNON, Joseph: 'Proximate Vision' *Art in America*, New York, May 1982, pp.101–105

SHAPIRO, Harriet: 'Arikha' *People*, New York, May 19, 1986

STEVENS, Mark: 'The Art of Ambush' *Newsweek*, 2 July 1979, pp.84–85

STEVENS, Mark: 'The Rights of the Eye' *The New Republic*, Washington, July 13 & 20, 1992, pp.40–42

STONE, Peter: 'From Life' *Jewish Chronicle*, London, 24 Feb 1974

SZE-TO. LAP: 'The Painter for Painters II – interview with Avigdor Arikha' in *Twenty-First Century Bimonthly*, The Chinese University of Hong Kong, vol.VI, August 1991, pp.58–68, repr. (some inverted) and back-cover (Chinese)

TAKASHINA, Shûji: *Resonance of the spirit in Arikha*, catalogue introduction, Marlborough Fine Art, Tokyo, 1988, (Japanese and English)

TAMMUZ, Binyamin: 'Tsiurei Arikha leRilke', *Haaretz*, Tel Aviv, 20 March 1953 (Hebrew)

THOMSON, Duncan: in *Great Scots*, Scottish National Portrait Gallery, HMSO, Edinburgh 1984, pp.1, 70

THOMSON, Duncan: 'Duncan Thomson Talks to Avigdor Arikha', *Modern Painters*, London, May 1990, vol.3 no 1, pp.108–109

THOMSON, Duncan, 1994: see monographs

TUCK, Lon: 'Drawing the Line at Abstract Art – The Commonplace Subjects and Bold Brushstrokes of Avigdor Arikha', *The Washington Post*, 16 June 1979, section B, pp.1–2

VIATTE, Germain: entry on 'Studio Interior with mirror, 1987' in *L'Art Moderne à Marseille La Collection du Musée Cantini*, Marseille, 1988, p.200

WEINER, Julia: 'Domestic appliance' *Jewish Chronicle*, London 20 May 1994

WOIMANT, Françoise: 'Arikha', *Les Nouvelles de l'Estampe*, Bibliothèque Nationale, Paris, 1975, pp.20–22

WOOTON, David: 'Beyond Abstraction' *The Art Book*, p.5 and cover, vol.1 No4, London 1994

AWARDS AND HONOURS

Gold Medal, *10th Triennial*, Milan, 1954
Chevalier des Arts et Lettres, Paris, 1978
Grand Prix des Arts de la Ville de Paris, Paris 1987
Prix des Arts, des Lettres et des Sciences, Fondation du Judaisme Français, Paris, 1988

HONORARY DEGREES

Honorary professor, *National Academy of Fine Arts of China*, Hangchow, 1995
Doctor Phil.H.C., *Hebrew University*, Jerusalem, 1997

AVIGDOR ARIKHA (b. 1929) lives mostly in Paris, partly in Jerusalem.

MARLBOROUGH

LONDON

Marlborough Fine Art (London) Ltd
6 Albemarle Street
London W1X 4BY
Telephone: 0171-629 5161
Telefax: 0171-629 6338

NEW YORK

Marlborough Gallery, Inc.
40 West 57th Street
New York, NY 10019
Telephone: 1-212-541 4900
Telefax: 1-212-541 4948

TOKYO

Marlborough Fine Art Ltd Tokyo
4-30, Minami Aoyama 5-chome,
Minato-ku
Tokyo 107
Japan
Telephone: (03) 3498 9795
Telefax: (03) 3498 9796

MADRID

Galeria Marlborough, S.A.
Orfila 5
28010 Madrid
Telephone: 34-1-319 1414
Telefax: 34-1-308 4345

SANTIAGO

Galeria A.M.S. Marlborough
Nueva Castanera 3723
Santiago, Chile
Telephone: 56-2-228 8696
Telefax: 56-2-207 4071

HONG KONG

Marlborough Fine Art (Asia) Ltd
709 Yu Yet Lai Building
43-55 Wyndham Street
Hong Kong
Telephone: 852-2877 9229
Telefax: 852-2526 9306

LONDON

Agents for
Frank Auerbach
Christopher Bramham
Steven Campbell
Lynn Chadwick
Chen Yifei
Stephen Conroy
Christopher Couch
John Davies
Daniel Enkaoua
Dieter Hacker
Maggi Hambling
Bill Jacklin
Ken Kiff
R. B. Kitaj
Christopher Le Brun
Raymond Mason
Thérèse Oulton
Victor Pasmore
Celia Paul
John Piper
Sarah Raphael
Paula Rego
The Estate of Oskar Kokoschka
The Estate of Graham Sutherland

IMPORTANT WORKS AVAILABLE BY
Impressionists and Post-Impressionists
Twentieth Century European Masters
German Expressionists
Post War American Artists

Modern Masters and
Contemporary Graphics
available from
Marlborough Graphics

Photographs by Avigdor Arikha
Catalogue no. 496
ISBN 0 900955 732
© 1998 Avigdor Arikha

NEW YORK

Agents for
Magdalena Abakanowicz
John Alexander
Avigdor Arikha
Fernando Botero
Claudio Bravo
Grisha Bruskin
Vincent Desiderio
Rackstraw Downes
Richard Estes
Red Grooms
Israel Hershberg
Alex Katz
Marisol
Tom Otterness
Arnaldo Pomodoro
Larry Rivers
Guillermo Roux
Altoon Sultan
James Surls
Neil Welliver
The Estate of Jacques Lipchitz
The Estate of James Rosati

MADRID

Agents for
Juan Genovés
Francisco Leiro
Antonio López Garcia
Lucio Muñoz
Daniel Quintero
Joaquín Ramo
Antonio Saura
Manolo Valdés

Designed by Derek Birdsall
Typesetting and production by
Omnific Studios/London
Printed in England by Balding + Mansell